You Can Paint
Vibrant Watercolors
in Twelve Easy Lessons

Yuko Nagayama

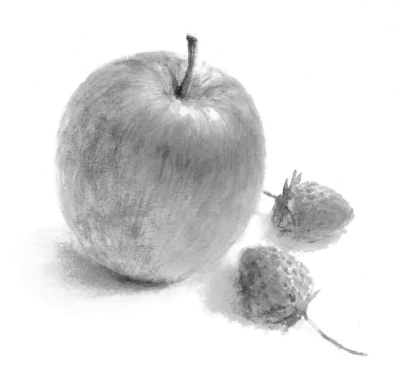

HARPER
DESIGN
An Imprint of HarperCollins Publishers

Table of Contents

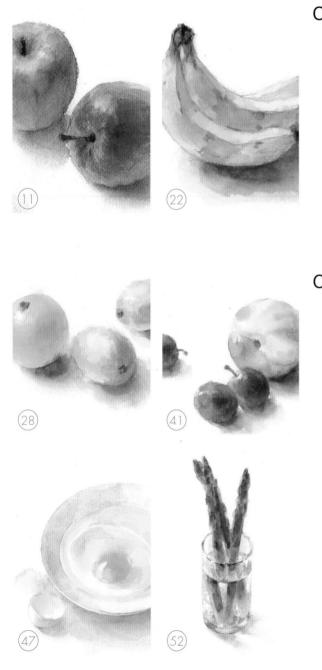

Chapter 3: Techniques for Drawing Dishes and Bottles— Two Lessons

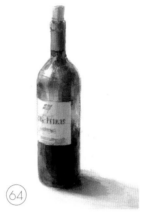

Chapter 4: Drawing Flowers— Two Lessons

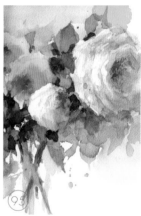

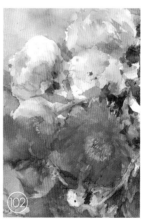

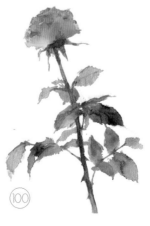

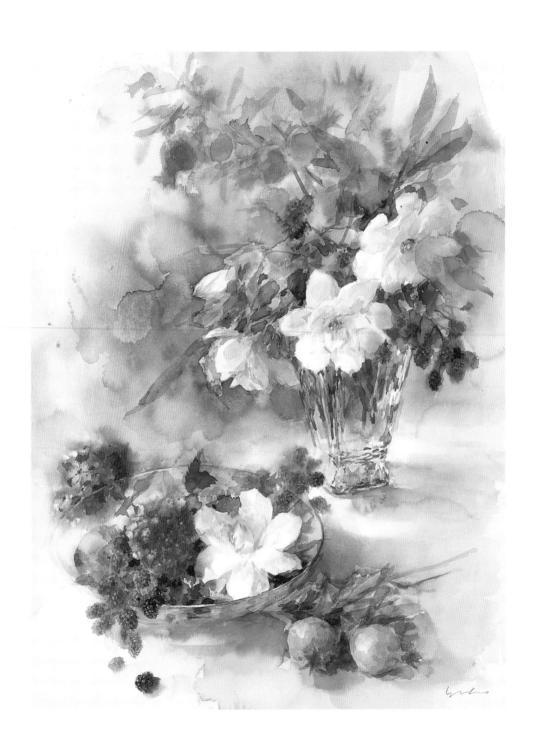

Hatsu Natsu (Early Summer)
69 x 52 cm / 27.2 x 20.5 in.

Chapter 1

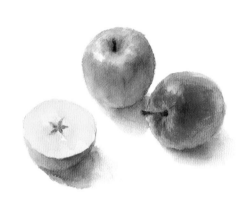

Motif—Apples

What Does It Mean to Learn Watercolors Once Again?

Most people have painted in watercolors while attending elementary school or in junior high school.

Unlike with Japanese-style painting and oil painting, anyone can paint watercolors without learning how to use special paints and tools—they just need water-based paints, brushes, and water. Suffice it to say that watercolor painting is an attainable popular art.

However, despite its simple nature, when you actually try watercolors—unexpectedly and surprisingly—it is not that easy at all. Those who have been painting in oils for many years say that "because watercolor painting cannot be repaired, it is difficult."

Capturing shapes and determining light and shade is the same as in other types of painting. However, it is seemingly simple, to actually use transparent watercolors in a practical manner to accomplish an airy and translucent painting is quite difficult.

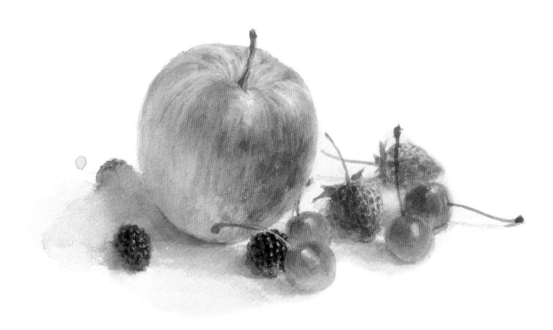

In This Book, You Will Learn

What kind of apples do you draw? The following shows the stages of improvement that will allow you, through gradual learning, to paint in such a manner.

1

When told to paint an apple, people often paint it like this—an apple is round and it is red. However, it looks as if it is just a symbol for an apple—flat like an appliqué.

2

When carefully looking at a nearby apple, you will notice that there are portions that are yellowish-green. Observing this carefully and painting the color differences thoroughly makes the apple realistic. Now it passes for an apple illustration, but it still does not look as if an apple is right in front of your eyes.

3

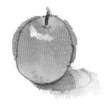

That's right! If there is shade, the apple becomes even more realistic. But it still feels a little weak "to the touch"...

4

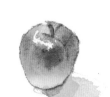

By touching an apple, you will realize that it is actually a pentagon. Paint this shape by placing emphasis on the nearest outward-pointing corner. Painting what is discovered through observing is the first step in painting.

5

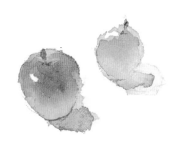

Once you can paint one apple, the next step is to paint two apples. Deciding which will be near to you and which will be far away allows you to paint not only the apples but also the atmosphere around them. When you are able to bring out a sense of perspective, then you've got it. Give it a try and it will broaden your horizons!

You have to learn a certain way of observing and painting objects in order to be able to paint the apples in stages 4 and 5.

Things to Do Before You Draw

First, Touch an Apple with Both Hands

Did you feel any slightly angular parts?

If you did not feel them, turn the apple upside down and touch the bottom. Did you feel that there are five bulges?

Let's cut the apple in half widthwise. This is not really the direction you usually cut in, but what kind of shape jumps out at you?

That's right—the five carpels (casings for each seed). Note that apple blossoms have five petals as well.

Well then, at the blossom end, let's pick out the remains of the apple blossoms. They are called sepals. Did the pistil and stamen pop out at you?

Sometimes, there are even apples that still have their petals attached. For the next experiment, please pick up an apple by pinching its stem.

Try to keep pinching it for ten minutes. It's hard, isn't it? For months this apple was hanging from a tree by nothing but this stem until it ripened. The stem is exactly like an umbilical cord. Which is to say, it should not be painted sloppily and timidly.

Please look at the color of the stem. Is it brown? It might be yellowish green mixed with red and orange. It is not a simple brown.

Well, now that our observation period is complete, let's start to paint!

Pencils for Sketching

I use HB, F, or 2B graphite pencils. Using a pencil sharpener is suitable for colored pencils, where the lead is easily shaved off, but for a sketching pencil it is not suitable.

Sharpen the pencil with a utility knife and leave the graphite exposed about 1 cm (0.39 in.). Unlike copying paper, watercolor paper has a rough texture so the pencil lead wears out quickly.

Use a kneaded eraser; tear off a piece that is easy to handle. You can press it onto the paper to erase lines or to make your pencil lines lighter.

* Actual size.

How to Sketch

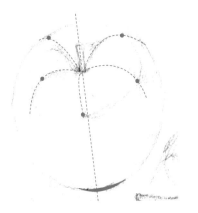

1

Determine the general shape of the apple by touching its five corners. Don't forget that there are five carpels inside an apple that is cut widthwise.

At this point, let's also draw the position of each shadow on the table. Noticing things and adding them after the fact can lead to a sketch that is poorly composed.

Point

Habitual observation in order to grasp even the shadows that are a part of the motif is very important.

Coloring Procedures

* Color names are provided as a reference when trying each lesson. (Please refer to page 15.)

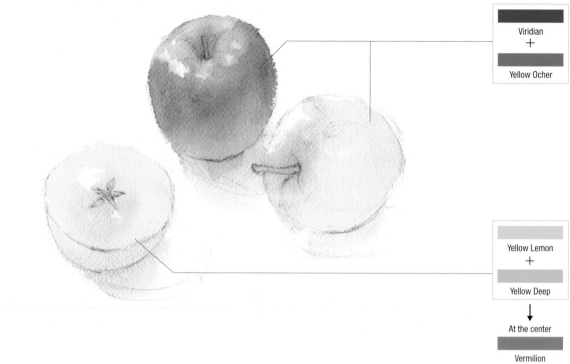

Viridian
+
Yellow Ocher

Yellow Lemon
+
Yellow Deep
↓
At the center

Vermilion

1

Paint in some yellow where the apple looks yellow. When dissolving watercolor paints, use more water for each of the lighter parts and use less water for the darker parts. Next, add other colors as the yellow diffuses.

Observing Apples Once Again

Red apples are not just red. When you look closely at them, you should see pale yellowish-green mixed in with the red of the peel.

In particular, the cavities around the stem and at the blossom end—where the sun cannot shine—do not become red. The color from before the apple ripens remains.

Whether you are able to notice things like this or not is a crucial point. The red from the apple that is next to the green apple is seen reflecting on the green apple's surface. We must pay attention to these details as well.

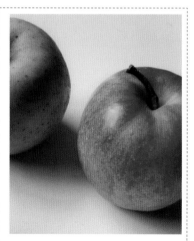

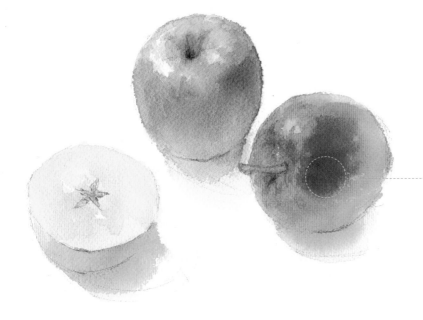

Crimson Lake

2

Put down some red paint. Don't just paint it flat. Since the nearest front corner of the pentagon is pointing outward and is darker, you must paint it boldly.

This is not done by putting down many layers of color. Bring out this tone once only. Remember that the red apple reflects on the green one.

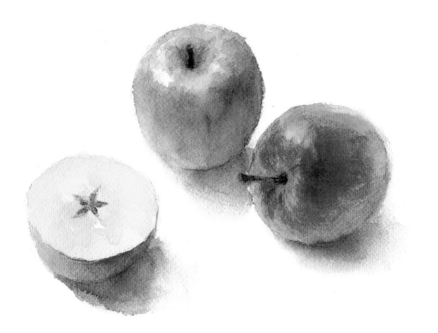

Cobalt Blue
+
A little
Yellow Ocher

Complete.

Add shadow to complete.

About Paints

Sets and Single Color Tubes

For total beginners, it is better to purchase a set of 24 colors and add a few other colors to the set.

Though I think Holbein sets, etc., are easy to use, it is good to supplement your set of paints with single tubes imported from Winsor & Newton or Schmincke, even if they are not from the same manufacturer. As long as they make you think "I want to use that color," then it is okay to mix paints from different manufacturers.

At this point, there is one thing to watch out for. You must take care with certain paints in a set, like Jaune Brillant (the so-called skin-tone color) and black.

For total beginners, it is better not to put these two colors in your palette yet.

Since beginners think of Jaune Brillant as the skin-tone color, it is likely that they will use it as is whenever they paint flesh.

However, actual flesh has a much more complex expression. It is better to study how to bring out true flesh colors by painting in layers, which is unique to transparent watercolors, and just remove Jaune Brillant for now.

As for black, some people mix it with other colors in order to paint darker parts of their works, but doing so makes the mixed color turbid and makes the shade lose its transparency. When you look closely, you can find colors everywhere, even in dark shadows. By mixing colors and painting in layers, let's practice making dark colors while preventing our paintings from becoming turbid.

In rare cases, using black as a single color, some people are able to paint in an effective and attractive way.

If you remember to "not mix in black just because it is dark" and pay attention to how black is actually used, it might become your forte someday.

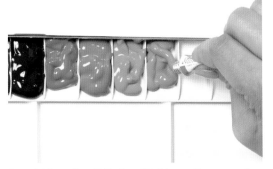

Put paint in each well. Each well holds exactly one small tube (5 ml.) of paint.

The picture above shows a set of paints on a palette. The main colors are from a Holbein set of 24, but I exchanged "Opera" and "Lavender" (for black and Jaune Brillant)

Putting Colors on a Palette

When you put paints on a palette, rather than neatly arranging them just put on as much as possible and leave them out for about two days to dry. If you pick up your palette right away, the paints may leak, even if the paint's surface looks dry.

Careful—if you treat paints too preciously, they just end up drying in the tube. That is such a shame!! Also, when you only have a little paint on your palette, bold and spontaneous strokes are difficult. Say you want to make a blue background with a lot of depth one day, if there is not enough paint, then you can only make a pale and vague background.

With 5 ml. tubes, I just squeeze all the paint out! Even when adding paint to the palette, I squeeze out a lot.

From the left bottom corner of the top half of the palette:
❶ Chinese White
❷ Permanent Yellow Lemon
❸ Permanent Yellow Deep
❹ Vermilion Hue
❺ Opera
❻ Crimson Lake
❼ Rose Madder
❽ Mineral Violet
❾ Cobalt Blue Hue
❿ Ultramarine Deep
⓫ Compose Blue
⓬ Cerulean Blue
⓭ Cobalt Green
⓮ Permanent Green No. 1
⓯ Viridian Hue
⓰ Permanent Green No. 2
⓱ Terre Verte
⓲ Yellow Gray

From left on the lower half of the palette:
⓳ Yellow Ocher
⓴ Burnt Sienna
㉑ Light Red
㉒ Burnt Umber
㉓ Prussian Blue
㉔ Lavender

Lesson Basics

If You Decide to Paint Apples, First of All Grab Some Apples

It is not acceptable to paint by looking at a photo. There is a reason why you paint *your* apples. For those of you who have apples on hand right now, hold them up and give thought to why exactly you are choosing these particular apples to paint.

In my case, I have a staring contest with lots of apples at the local supermarket or fruit store. In the end, I choose apples that have a distinct pentagon shape, are firm, crooked but with character, and fresh so the stems stand straight up. I am really envious of those who have the chance to paint apples that are still attached to the branch and irregularly shaped apples that have fallen from the tree.

Paint Full-size

In order to paint full-size do not use a small-sized sketchbook, such as postcard-sized or F4-sized (33 cm x 24 cm / 13.0 in. x 9.4 in.); rather, choose a sketchbook that is from F6-sized (41 cm x 33 cm / 16.1 in. x 13.0 in.) to F8-sized (46 cm x 38 cm / 18.1 in. x 15.0 in.). In this book you will learn motifs that can be painted primarily on F6-sized paper (41 cm x 33 cm / 16.1 in. x 13.0 in.).

If you use postcard-sized paper or F4-sized paper (33 cm x 24 cm / 13.0 in. x 9.4 in.) to depict "an apple that is in front of my eyes," simply painting the apple fills up all the space. This means that overall composition cannot be properly studied.

When painting a single apple on F6-sized paper (41 cm x 33 cm / 16.1 in. x 13.0 in.) you may think that there is lots of space to fill. However, an apple is a combination of an apple and its shadow. Only by thinking this way can you properly show that there is an apple on a table. In addition, the painting changes completely depending on where the apple is placed. Remember, it may be just a simple apple, but it is still an interesting motif.

Use F6-sized (41 cm x 33 cm / 16.1 in. x 13.0 in.) watercolor paper. The sketchbook shown in the photo above is paper block type. It does not buckle much even when water is used. As for your brush, if you are a complete beginner, I think that a brush shaped like a calligraphy brush is easier to get used to. For underpainting, use a flat brush to prevent excessive detail. For painting large spaces, use a paintbrush. They always come in handy.

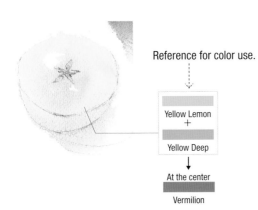

Reference for color use.

Yellow Lemon
+
Yellow Deep

↓

At the center

Vermilion

"+" indicates that you should paint after mixing two colors or more on a palette. "↓" indicates the color to paint over the colors painted prior while allowing the color to bleed.

The figure above followed this procedure: Mix the two yellow colors on a palette and then paint. Before the first paint dries, place some red into the center and allow it to mix on its own.

Add These Four Colors to a Set of 24 Colors

(From top) Holbein's "Opera," "Lavender," Kusakabe's "Passion Orange (or Schmincke HORADAM's Cadmium orange deep)," and Winsor & Newton's "Manganese Blue Hue."

Concerning Color References

Color References are listed on the leading pages that introduce procedures in this book. Since I would like you to paint freely, this is introduced only as an example of color use (they are just a reference). The references given were mainly chosen from the basic colors in a set of 20, as well as four supplemental colors in total 24 colors.

Note: Holbein's Transparent Watercolor paint names are given for each color. Some of them are abbreviated.

The color names given in this book → the color name of the paint: Vermilion → Vermilion Hue, Cobalt Blue → Cobalt Blue Hue, Yellow Lemon → Permanent Yellow Lemon, Yellow Deep → Permanent Yellow Deep, Viridian → Viridian Hue, Green No. 1 → Permanent Green No. 1, Green No. 2 → Permanent Green No. 2

Having Single Direction Lighting Is Important When Arranging Motifs

Place motifs as close to the window as possible and turn out the lights in the room when you paint during the daytime at your house. Sunlight shows rich colors like no other source of light.

Preparing a spotlight (use a clip-on type or a desk lamp) when painting in a room or at night enables you to change the direction of light according to the desired motif.

Of course, it is fine to use room lighting alone. However, if there are many lights in a single room, shadows will look doubled or tripled. So, when arranging a motif, please choose a room where the motif's shadow is easily seen.

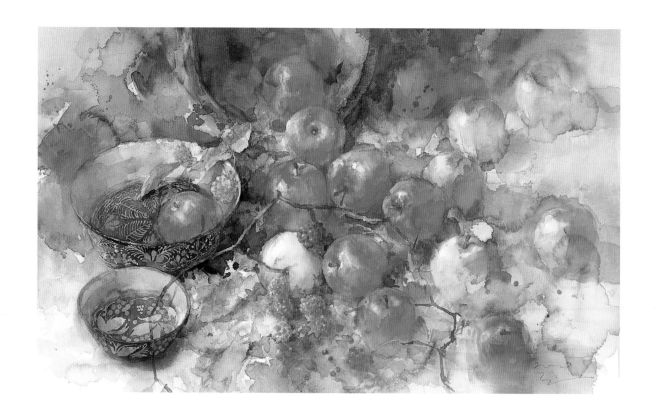

Rossiya no Uta (Rossiya's Song)
44 x 69 cm / 17.3 x 27.2 in.

The apples were sent from Shinshu (Nagano Prefecture).
In order to get completely crimson apples, twist the stem of each apple to change its direction and nip leaves off to expose the apples evenly to the sun. I find myself thinking that these apples were grown with lots of love every time I see them.

Chapter 2

Drawing Ordinary Foods
Eight Lessons

Banana

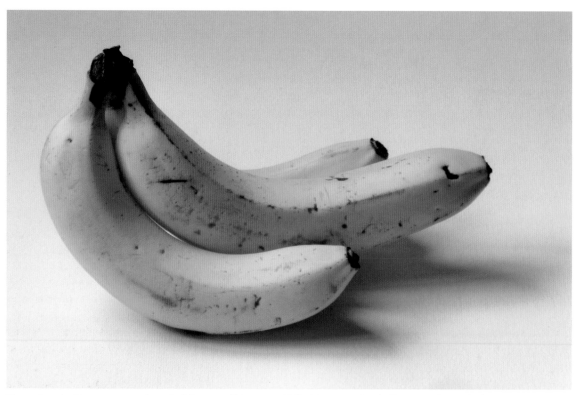

Place a bunch of bananas on a piece of white paper. Using a pencil, first draw a rectangle the same size as the bananas.

Procedures and Points

In the beginning use straight lines as much as you can to draw.

Check the frame of the rectangle and the tip of the banana.

Map out the overall shape.

Hereafter, use curved lines to draw.

Rough sketch.

❶ - - - - - -> **❷** - - - - - -> **❸** -> **❹**

Starting with a lighter color paint both the shadow and the banana together.

Add shading in one stretch as well.

After the paint has dried, lay in darker colors.

Lastly, paint in bruises on the banana.

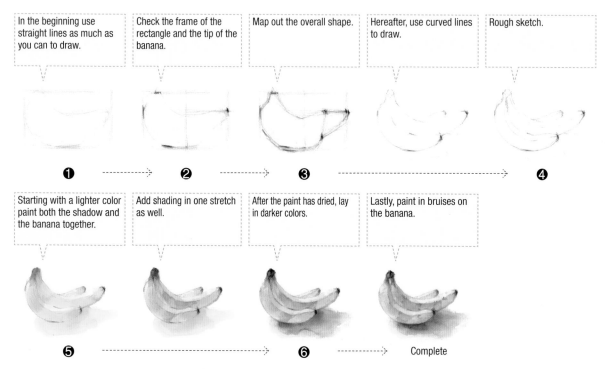

❺ -> **❻** - - - - - -> Complete

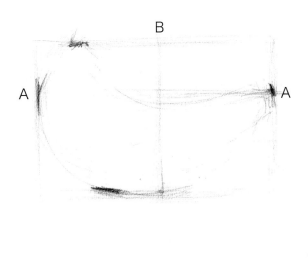

1

At first, draw a rough outline of the bananas. Then, draw a large rectangle around the parts of the bananas that bulge out most at the top, bottom, left, and right.

2

Gauge the spot where the bananas bulge out most for each side of the rectangle. Widthwise, the most bulged-out sections of the bananas are at about the position of line A, but at the bottom the bulge is left of center, line B. Find these positions on your bananas by drawing in an A and B.

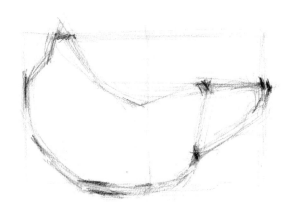

3

Draw straight lines to map out the complete shape as if you were covering the bananas with plastic wrap. Draw the bunch without drawing any individual bananas.

4

Finally, draw everything with curved lines.

Point

Start with straight lines, and then use curved lines when mapping out a shape.

19

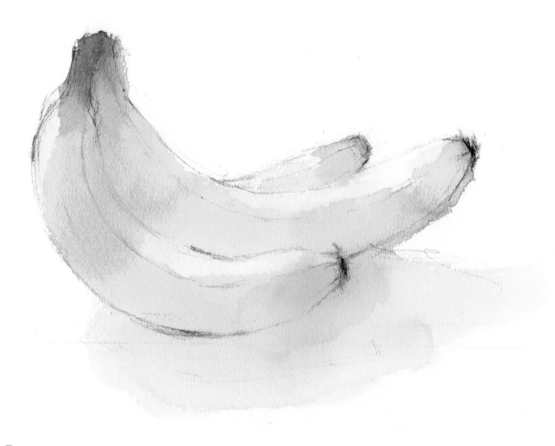

5

After lightly painting all the yellow portions, add yellowish-green and darken the yellow where needed. While the surface is still wet, blot the lighter sections with a facial tissue.

Yellow Lemon	Yellow Deep
Green No. 1	Burnt Umber

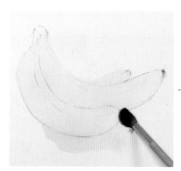

Begin. Paint both the bananas and shadow.

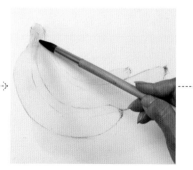

Paint all visible colors by starting with the lightest color.

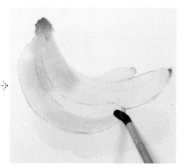

Paint the parts where yellow becomes darker.

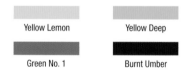

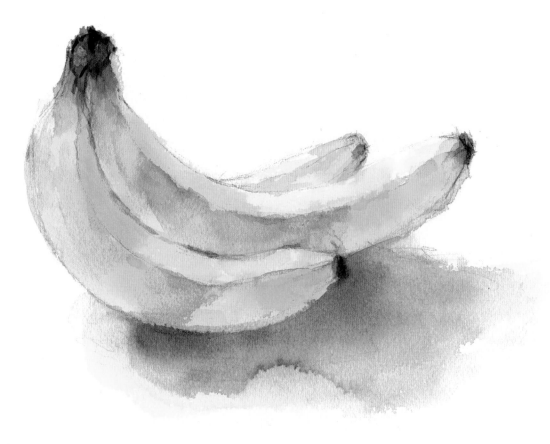

6

Furthermore, add colors to the darker parts and to the shadow. This time I placed a piece of white drawing paper beneath as a motif. When bananas are placed directly on top of a wooden table, the shadow of the motif becomes brown due to reflection.

Banana

Passion Orange	Yellow Deep

Shadow

Ultramarine Deep	Mineral Violet

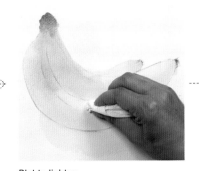

Blot to lighten.

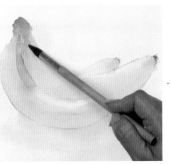

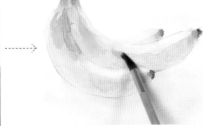

Add color to the darker spots of the bananas.

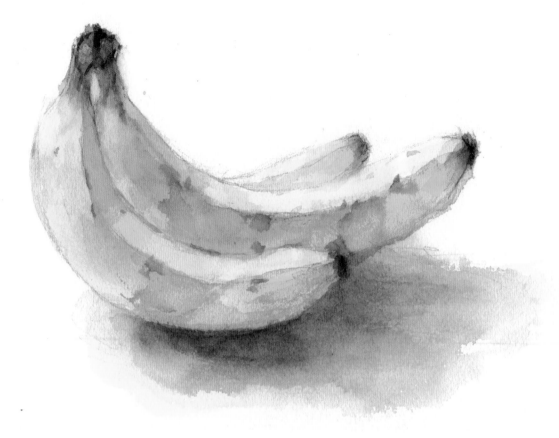

Complete

Draw in the bruises, etc., at the end, after light and shade are added.

Burnt Umber

Just Bananas? Please Don't Make Light of Them.

When I was in elementary school, bananas were served for lunch. The banana served one day was curved. The next day's was straight. Which one is better? Being greedy, I was always wondering whether a curved banana or a straight banana was longer. While I was painting bananas, such memories came back to me and suddenly I realized something. Bananas that are inside the bunch are straight and the banana next to it laps over as if wrapping around the inside banana. The outer side curves more. That is all I have really figured out, but I am still not sure which shape is better—straight or curved.

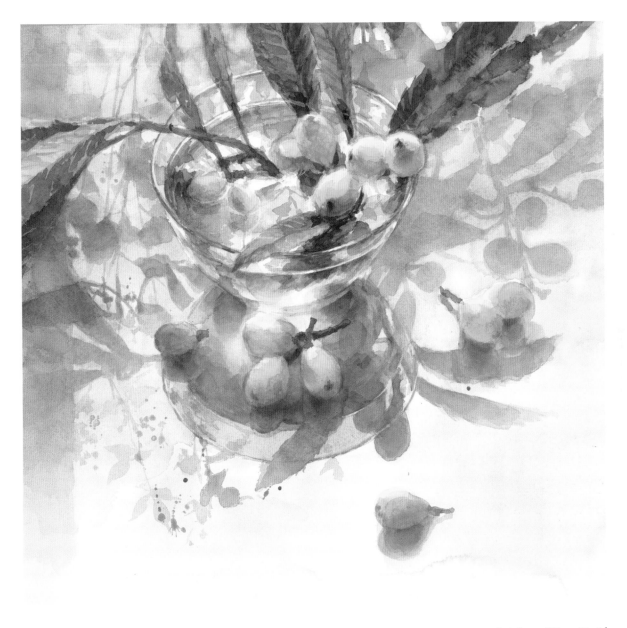

Aoi Sora (Blue Sky)
45 x 43 cm / 17.7 x 16.9 in.

In order to prevent colors from becoming muddy through excessive layering, make efforts to leave plenty of the first color as a base. In the beginning, lay the color as brightly and boldly as possible. You must be thinking, "Isn't the first application lighter?" Well, does the first color remain when the painting is completed? Thinking that "it was light, so I should deepen it," and then laying on a base color too many times will result in ruining the beautiful shade of the initial paint. The light spots and the dark spots must be distinguished clearly at the underpainting stage.

Oranges and Lemons

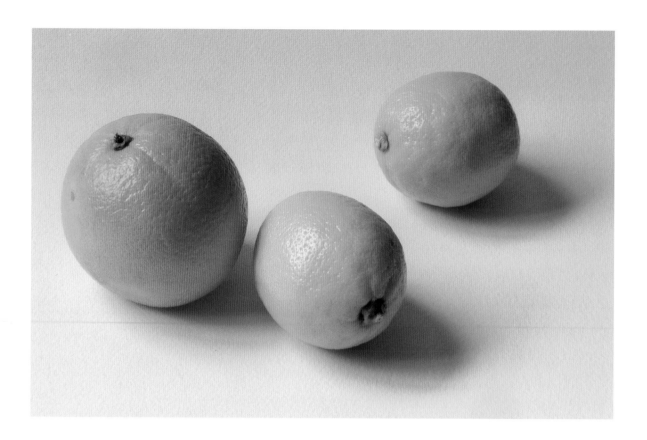

Procedures and Points

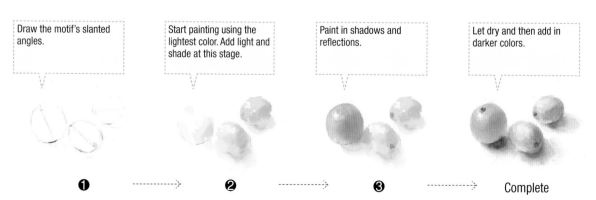

Draw the motif's slanted angles.

Start painting using the lightest color. Add light and shade at this stage.

Paint in shadows and reflections.

Let dry and then add in darker colors.

❶ --------> ❷ --------> ❸ --------> Complete

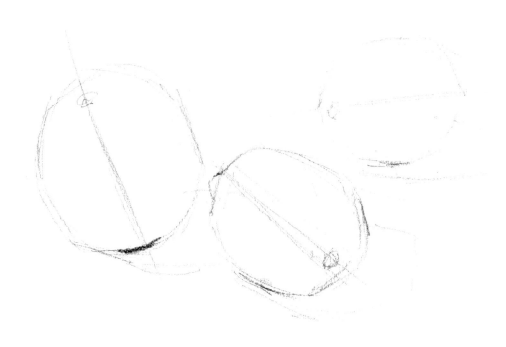

1

Oranges and lemons. Draw lines and map out the shapes by imaging the slanted angle of each motif. *These lines will soon be erased. They are there to help maintain shapes by determining the angle at which the orange is slanted.

① The center line.
② Contact point.
③ Shadow on the ground.

Let's confirm all the important lines to draw.

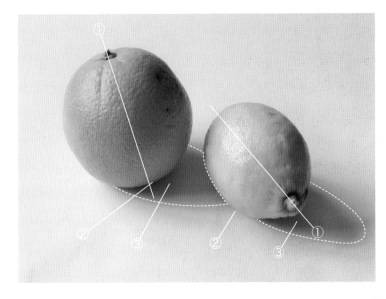

2

Start by painting the brightest color, yellow. Leave the drawing paper white to make the brightest spots of the lemon. By blending in some cobalt-green, like a secret ingredient, the sourness of citrus fruits can be highlighted.

Rose Madder	Yellow Lemon
Yellow Deep	Cobalt Green

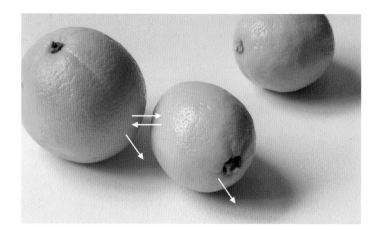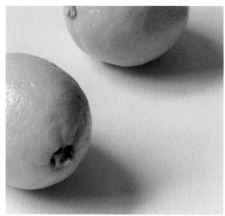

While you are painting, it is important to look closely and think, "Does this color reflect somewhere?" If you look really closely, you will see that the yellow of the lemons reflects in the shadow. Since the lemon also reflects on the orange, add a little yellow there too.

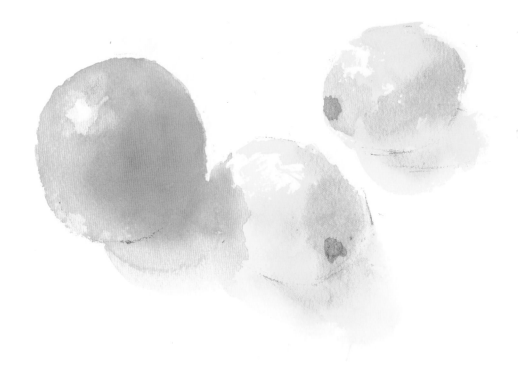

3

Don't forget to add paint where the orange reflects on the lemons and in the shadow. Do not paint it flat and thick. Instead, make a sphere by focusing paint on the brighter and darker spots.

Yellow Deep
+
Opera

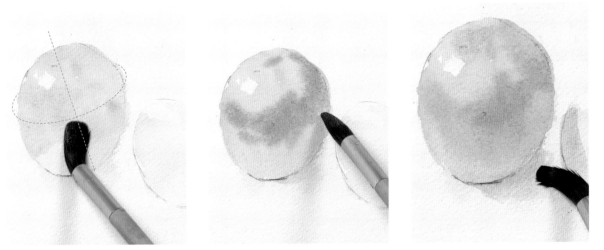

Layer the colors while wet: Paint the bulge a little darker, and then move your brush over to the shadow and the lemon.

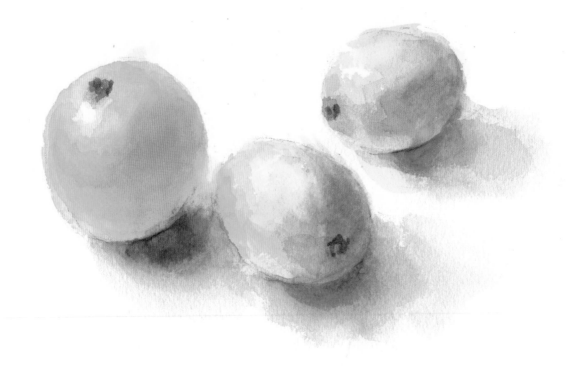

Complete

For the shadow beneath the fruit, layer on a light-purple type
of gray.

Shadow
Mineral Violet
+
Lavender

I Am Often Asked, "What Color Is Shadow?"

The color of a shadow cast on the table is, in reality, an intrinsic color of the
motif plus gray. Since the motif is placed on a table, i.e., they are touching
each other, the color of the table always reflects and the motif is tinged
with that color. Plus gray: This is not a gray that is simply white and black
mixed together. It is a gray that contains various colors. There are those
who always use "Payne's Gray" when painting shadows. Certainly that is a
convenient color, but there are surely colors that exist within darkness and
shadow. Creating a nuanced gray for shadows is where your skill comes
in. If the color of shadow painted first is a warm color, then for the second
coat, lay down a cold color (or vice versa) to make the gray realistic. Then,
by laying a third color at the darkest point, a very deep gray can be created.

Painting Without Wasting Time and Effort

This book introduces a method for blending and painting all at once. Rather than laying down colors for a shadow many times over in order to make it gradually darker and bring out its roundness, this method allows you to finish painting smoothly and bring out each color's brightness.

Blending and Casting Light/Shadow All at Once

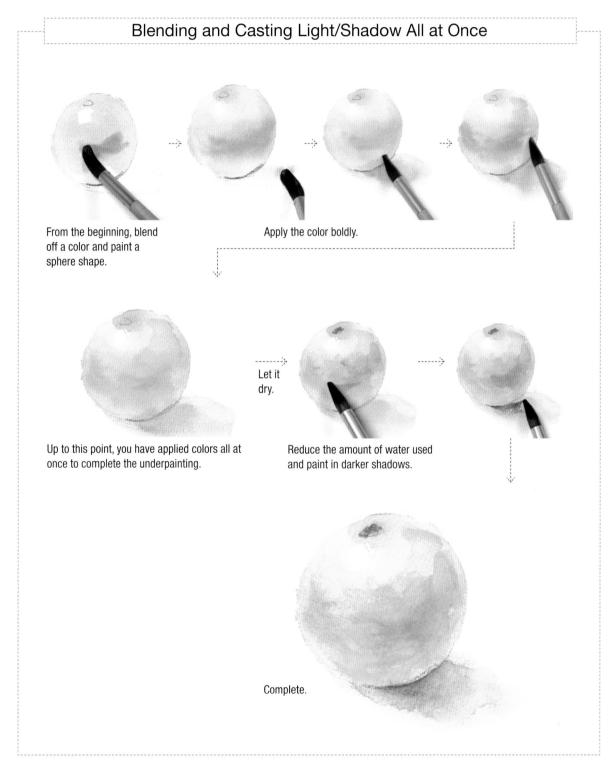

From the beginning, blend off a color and paint a sphere shape.

Apply the color boldly.

Up to this point, you have applied colors all at once to complete the underpainting.

Let it dry.

Reduce the amount of water used and paint in darker shadows.

Complete.

When the Table Has Colors

1

Begin by painting the lighter color first, similar to the process for "Oranges and Lemons" above.

2

When painting a tablecloth, paint its reflection on the motif as well.

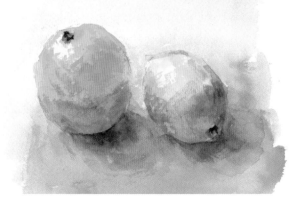

Complete

After the tablecloth color has dried, add further shadows to complete.

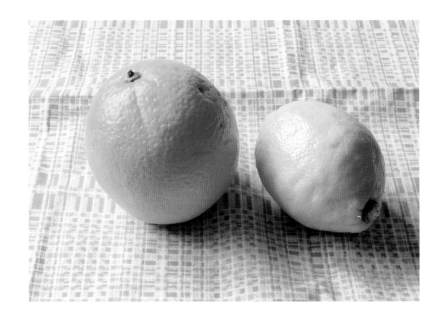

Objects Next to Each Other—Distance and Reflection

There is a phrase, "Let's look at the relationship between two objects." How close together are they; how far apart are they? If items touch each other, their colors will reflect. They interact with each other. When painting a tangerine, a lemon, and a piece of cloth, do not complete each one separately. Instead, apply colors to each one carefully while thinking about the question "where does this color reflect?" When you work this way, it looks as though the motif is neatly placed on a table and brings out the feel of items being placed close to each other.

The darkest shadow should be cast where the object touches the floor.

Mangoes and Grapes

Apples? Bananas? Grapes? People tend to think that it is easy to paint these things, but there is a trick to capturing their true shape. If you master the trick, you can apply it to other types of fruits and vegetables as well.

Don't think that "there are no instructions for painting strawberries, so I can't paint them." Rather, let's think, "Which trick should I apply for painting strawberries?"

When you learn a "method," you cannot paint items that you have not yet learned to paint. On the other hand, when you learn the "trick," the variety of items you can paint increases greatly.

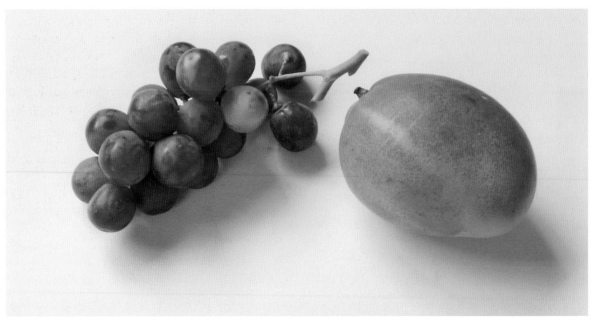

Procedures and Points

Form shapes using straight lines and mapping out proportions

After capturing the bulging outline, draw the front grapes.

Paint by first recalling the color of the flesh.

❶ ----> ❷ ----> ❸ ----> ❹ ----> ❺

Blot color onto the mango highlight.

Add grape shadows and highlights.

❻ ----> ❼ ----> ❽ ----------------> Complete

1

Try not to draw grapes individually. Capturing them as a whole is the trick. At first, map out the overall shape by drawing straight lines as if they were wrapped in plastic film. This is called proportional mapping.

Point ————————————————

Draw from the back! A landscape is drawn from the back. For example, you draw the sky, a mountain, a lake, and then the trees. The same applies to still life. Once the composition is fixed, start to map out the shape of all the objects in the back. In the figure above the "o" indicates each grape that sticks out.

2

Since the "o" marks each part that sticks out, you can form a contour beyond each of those points. Next, fill in the gaps.

3

Draw the grapes that look round and are entirely visible. The spots marked with an "o" help you to "locate the very front," i.e., where the grapes at these points are sticking out. They should be drawn in completely.

4

Draw the other grapes to fill in the gaps.

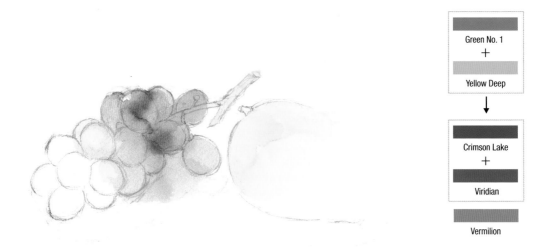

Green No. 1
+
Yellow Deep

↓

Crimson Lake
+
Viridian

Vermilion

5

If you mindlessly decide that grapes are purple, they will actually look phony. In reality, they may be navy blue or black or russet. First, lay the color for the grape's flesh inside the peel. While still wet, add a small puddle of slightly dark paint for the color of the grape.

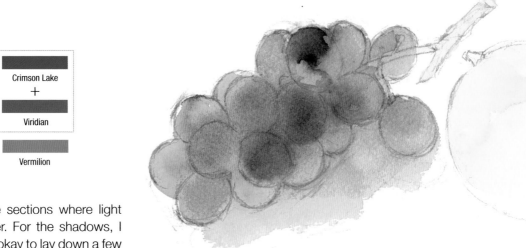

Crimson Lake
+
Viridian

Vermilion

6

Make the sections where light hits lighter. For the shadows, I think it is okay to lay down a few layers of any dark color.

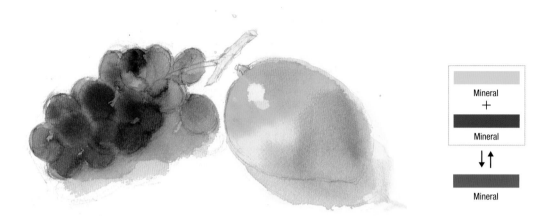

Mineral
+
Mineral

↓↑

Mineral

7

To get the mango color, let the following colors seep in before each dries:
yellow, green, and then red.

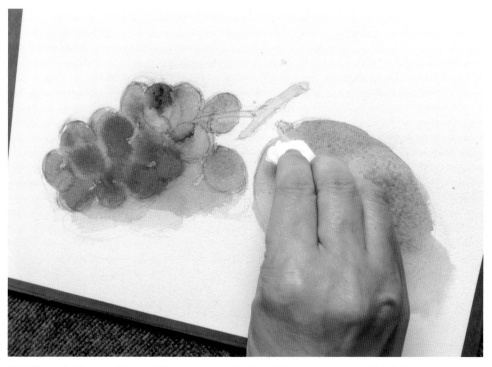

Blot the brighter portions of the mango with facial tissue to make highlights.

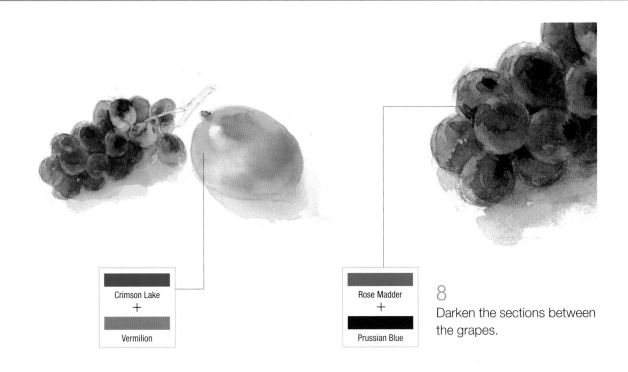

Crimson Lake
+
Vermilion

Rose Madder
+
Prussian Blue

8

Darken the sections between the grapes.

Chinese White

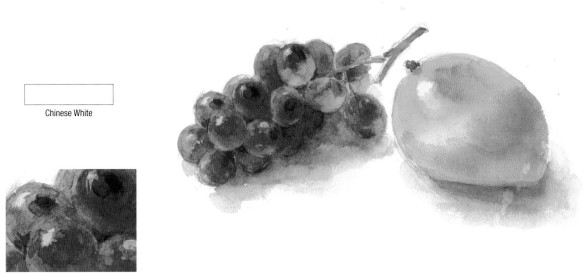

Complete

Finally, for highlights on the grapes, add an opaque white where they shine brightly. Of course, you can cautiously leave the drawing paper blank to produce highlights, but for small fruit like grapes, being overly cautious when leaving the paper white actually hinders the depiction of roundness. It is better to just use white paint.

Tips for Painting Fruit

In the apple chapter, we began by finding a good-looking apple with a nice pentagonal shape. I wanted you to know the basic shape of an apple. Now, using what you know, draw a few crooked apples of different sizes. The important thing to remember is that each one is different. Drawing while thinking "That one is not as ripe as this one" can bring about important changes in your drawing. It is better to emphasize distinctions a bit since that is what painting is all about. I do the underpainting by imagining the greenish appearance slightly before it reaches its current condition. The reason for this is that drawing the still greenish appearance and the ripe appearance allows me to capture the passage of time.

Combine Peaches and Plums

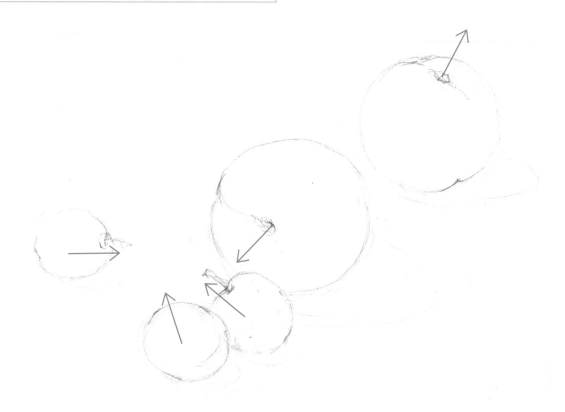

1

Fruit has a core/an axis. When fruit is strewn about, it naturally looks as if it is facing the direction of the axis. Add movement to your painting by making your fruit face different directions.

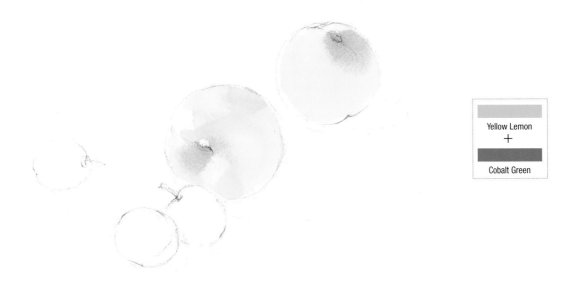

Yellow Lemon
+
Cobalt Green

2

There is no fruit more suitable for watercolor than peaches. Lightly infuse your yellow paint with water and paint the peaches. While still wet, paint yellowish-green where the peach is still green.

Crimson Lake
+
Vermilion

3

While still wet, wash red toward the core. Some peaches are more pinkish, and others are fused with an orange color. There is one secret, though, even for a red ripened peach: try to leave the yellow portion a little larger than it looks. If you just paint along joyfully and end up laying down too much red, before you know it the red will spread and transform the peach into a tomato or an apple.

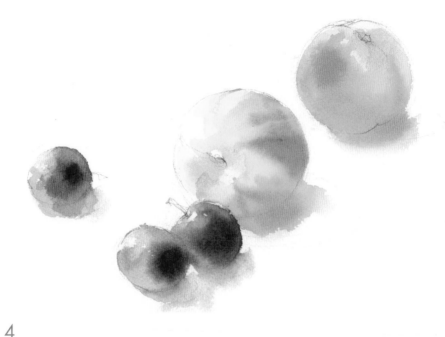

4

For the plums as well, recall the color when they are not yet ripe (usually, it is yellowish-green) and paint the unripe spot first. Blend in the color of the peel while the paint is still wet.

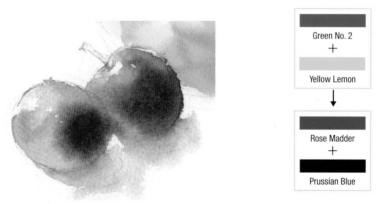

Green No. 2
+
Yellow Lemon

↓

Rose Madder
+
Prussian Blue

Are You Forgetting about Light and Shadow When You Look at Colors So Much?

Apples are red; lemons are yellow. The intrinsic colors jump right out at you. But if you paint only those colors, you can only paint flat coloring book-like fruit. Where is the fruit brightest and where is it darkest? We must observe closely. The trick is to gaze at the fruit while your eyes are squinted. By squinting, fine patterns and unevenness on the surface of the motif become hidden so you are able to find the broader light and shadow. When you paint, at first put this light and shadow down boldly on the painting surface. Should you gradually make it three-dimensional? No, that's not necessary. Roundness can be brought out with just one application!

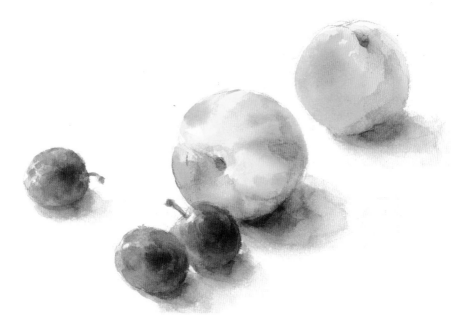

Complete

Layer on the shadows. Put white paint, mixed with Holbein's Lavender, where the plum appears glaucous and blot lightly with your fingers. Thinly apply transparent white paint to the contours of each peach in order to give the appearance of soft peach fuzz.

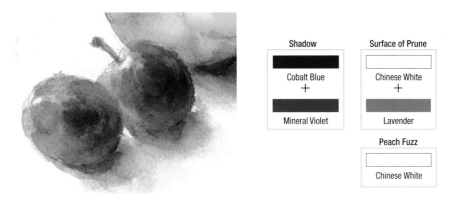

Shadow	Surface of Prune
Cobalt Blue	Chinese White
+	+
Mineral Violet	Lavender

Peach Fuzz
Chinese White

How Is White Transparent Watercolor Paint Used?

How should it be used? Some say not to use white paint for transparent watercolors, but I use it. On spots that I want to make sparkle and when I want to add thickness to a white object, I even dare to use white gouache. Also, for peaches' underpainting, I mix white and yellow transparent watercolors together to make a cream color and apply it. By doing so, those peaches appear realistic, just like peaches with fuzz. Also, for the frosted surface of grapes, plums, etc., white is necessary. Paint what you want to paint! If you try things that nobody else does and the outcome is wonderful, it becomes a skill that only you have.

Eggs

A major characteristic of transparent watercolor painting is that you can express "brightness" and "white" by simply leaving your paper white. This is similar to black-and-white painting. But for oil painting, Japanese-style painting, and acrylics, we use white paint for depicting white. For transparent watercolors, white paper itself transforms into the white petals of a lily, freezing snow, or the dazzling sun. This is the miracle of transparent watercolor painting—and it can be said to be a visually deceiving technique. By making the contours around paper really dark, your white becomes even brighter.

1

Now when you examine eggs in order to choose which ones to draw, you should realize that the color and shape is slightly different for each egg. Some are warm–colored and some are cold. The yolk inside and the conditions of the light can cause soft and wondrous colors. From sharply contoured to round eggs, the simpler their shape, the more you must be careful when you map out their shape.

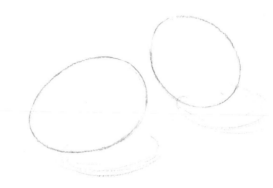

Opera
+
Yellow Lemon

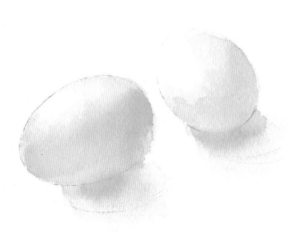

2

Since these are raw eggs, the warm color of the yolk inside is seen when light passes through.

Point
Bright… Dark… Bright by reflection. These three fundamental degrees of luminance are first clearly added in this stage.

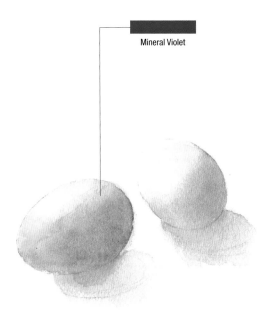

Mineral Violet

Manganese Blue
+
Thinly
Yellow Ocher

3
Learn to distinguish the different colors of eggs. Light purple, green, pink, etc. You will see many different colors.

4
The simpler they appear, the more difficult to paint them. Even after erasing the graphite outline, the egg looks round.

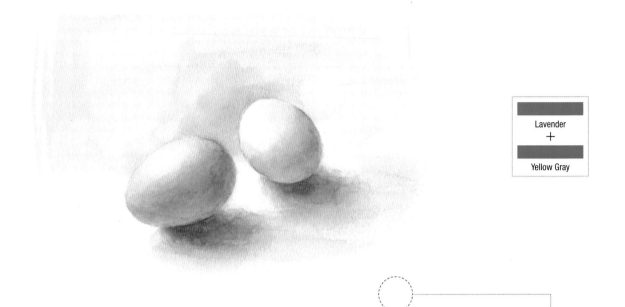

Lavender
+
Yellow Gray

Complete

In order to emphasize the white, lightly paint the background.

Please take a look at the painted eggs above. For both the bright spot of the eggs and the setting, the paper's natural color is preserved. They do not look to be the same degree of white, right? An optical illusion causes this (see below). Painting an egg is an excellent motif for learning to express white. By painting eggs carefully enough, you might even feel as if your eggs are being laid down with a little sound—plop.

Even the white of the same paper...

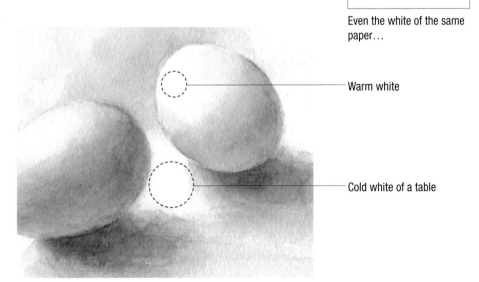

Warm white

Cold white of a table

Even though the same "paper white" is being used, if the contrast from the color next to it is great, the brightness leaves more of an impression and appears whiter.

The Pleasure of Watercolor Painting Is in Rediscovering Everyday Life

In both oil painting and Japanese-style painting, motifs that are available around you are painted of course. It's like "Oh, the light of this fruit is so beautiful, I must paint it before I eat it." Watercolor paints allow you to immediately capture these types of ideas, or one's feelings, in a painting. Just by preparing a little water, you can paint large areas quickly. And I think that watercolors are far better for expressing freshness than colored pencils and pastels. Of course, that is just my slightly biased opinion. Motifs surround you. The question is only whether you find them interesting or beautiful! It is all up to you.

If there is any suggestion that I can give, first I would suggest that you gaze at your motif under natural light. If you bring it out near the porch or put it by a window, many different colors will shine forth when bathed in sunlight. Especially items that are white.

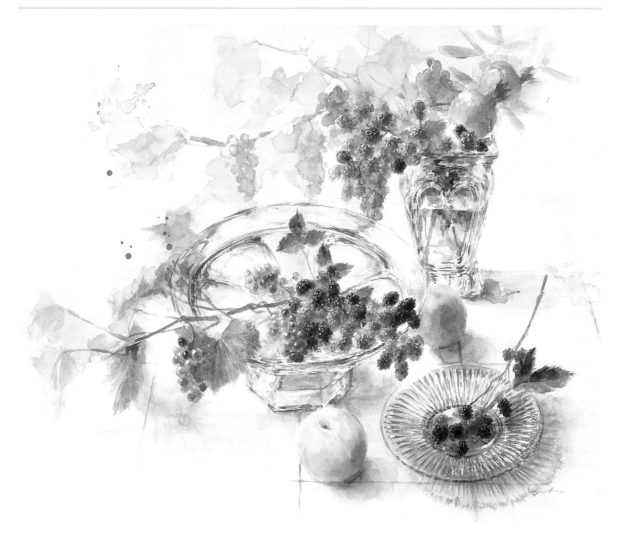

Shichigatsu no Onpu (Musical Notes in July) 60 x 88 cm / 23.6 x 34.6 in. |

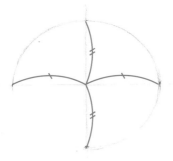

1

The oval shape of a dish may seem easy to paint, but it is actually quite difficult. Though the oval is just a regular oval, it becomes easier to draw if you insert a cross and put the necessary marks on it. For right-handed people, the right side is difficult to draw, and for left-handed people, it's the left. For drawing a large oval, it's okay to turn the paper as you draw each quarter of the oval.

2

Add the thickness of the dish.

Too fat

Too thin

I painted excessively and failed.

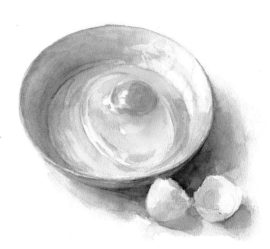

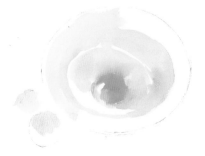

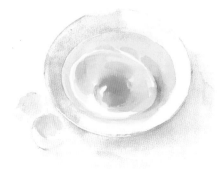

3

Use yellow, orange, and yellowish-green to paint everything in one stretch.

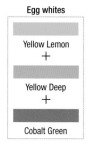

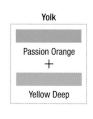

Egg whites	Yolk
Yellow Lemon +	Passion Orange +
Yellow Deep +	Yellow Deep
Cobalt Green	

4

While remaining aware of the fact that the light is coming from the left, let's look at lighting and shadow carefully.

Mineral Violet +
Lavender

Cobalt Blue

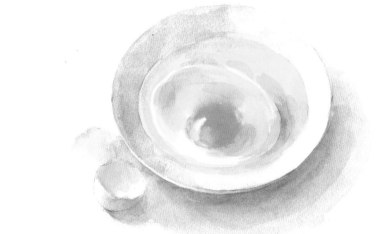

Complete

I thought this was easy and painted it. But even I failed twice. Simple objects are actually much more difficult to depict than complex ones.

Asparagus

Procedures and Points

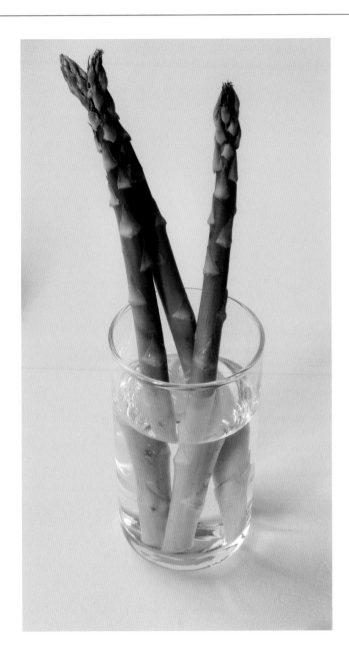

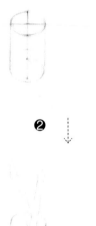

Search for its true shape while measuring.

❶

❷

Observe above and below the water separately.

❸

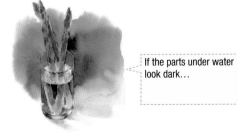

If the parts under water look dark…

❹

Complete

1

Using a pencil or ruler, take a measurement of the solid red arrow. Then, move down to measure how many lengths can fit in the glass. Here, it is two and a bit.

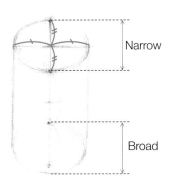

Narrow

Broad

2

Draw an oval. It should be a regular oval. Compared to the mouth, the base of the glass is a slightly larger oval. As it gets closer to the level of your eyes, the oval looks flatter. When it reaches the same level as your eyes it looks like a straight line.

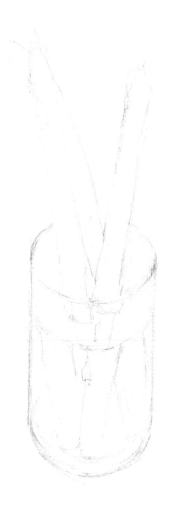

3

Do not paint asparagus carelessly in one stroke. Looking through a spot in the glass and through the water, you will see that each asparagus has a completely different aspect. Note that, in particular under water, as you approach the left and right side of the glass, the asparagus appears to expand.

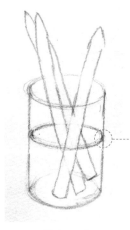

This does not show the thickness of the glass at all.

Not good

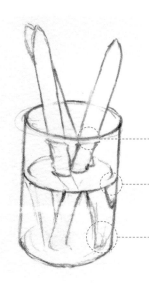

Here, due to a thickness of the glass, the asparagus looks as if it has shifted.

This is important!
This is where to illustrate the thickness of the glass.

As you move toward the sides under water, the asparagus looks expanded.

Good

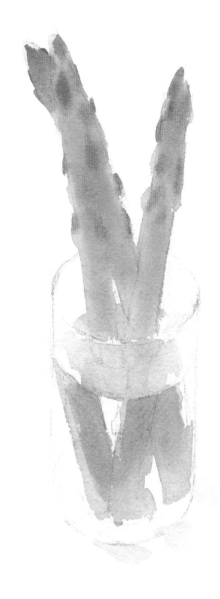

4

Paint asparagus. While the painting is
wet, paint in the buds.

Yellow Deep
+
Terre Verte
→
Rose Madder
+
Viridian

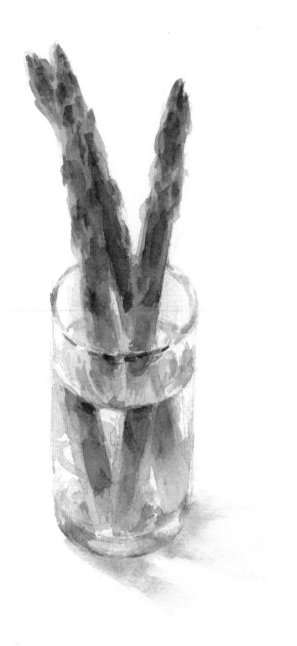

Complete

Some people paint glass, water, or transparent objects with light blue or vibrant blue. Though this may be enough to properly depict the quality of glass, thinking that transparency equals light blue and always using just blue will limit your notion of color usage.

Mineral Violet
+
Cerulean Blue

Asparagus

Green No. 1
+
Terre Verte

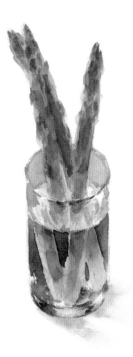

Though you carefully painted so you could see what was inside the glass, it turns out that the glass looks somewhat dingy and has lost its glassiness. Why?

Background

Viridian
+

Rose Madder
+

Prussian Blue

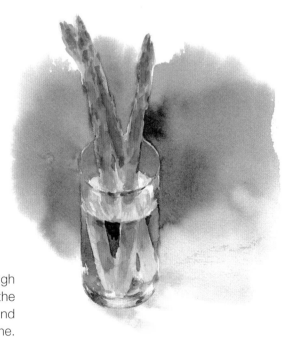

Answer

You can see the background through the glass. So, when the inside of the glass looks dark, the background should be painted at the same time. If it is not, the painting looks as if the motif was simply cut out and pasted on a white piece of paper.

Shortcuts for Improvement

Be Good at Receiving Praise

Have confidence in what you are praised for and steadily cultivate that confidence. This is the secret to improving. We Japanese have an ancient saying, "Modesty is a virtue." Thus, some people become extremely modest, even if they are praised. And there are even those who say that they cannot take anyone's praise seriously. Even when I am telling them what they have done is good they do not heed me and say, "Please tell me what is wrong—what should I correct?" They only pay attention to the shortcomings of their paintings. How disappointing! You are being praised for that which surpasses others, so be confident and please think of such positives as your assets. Increase those assets boldly. When your praise includes, "Your use of colors is good," then think what is it about my colors that is good—is it because "my colors are clear, not muddy" or "my blue background color is good." If your "blue background" was praised, please paint many paintings with blue-colored backgrounds and make it your specialty. Paint three different paintings and place them side by side. You should be able to judge by yourself which one is the best. Also, if you were told that "This glass cup is well done," then set up three glass cups and paint them. Or if you were told that "The quality of metals was captured well," then put metal objects together and paint them. That is a chance to build up your forte.

Be Confident

The type of confidence I am talking about is not "I am better than others." Also, please do not have an inferiority complex just because you are different. Do you feel at ease when you paint the same way as everybody else? Is it fun if everybody in your group paints identical paintings? In the world of painting, to paint in exactly the same manner as the person next to you is not highly regarded at all. Since each of us has our own mind, I would like you to have confidence and think, "It's okay for each painting to be unique. I will paint my own painting." Do not compare yourself with others. What is important is to be able to judge whether your painting is good or not so good by comparing it with your other paintings.

Chapter 3

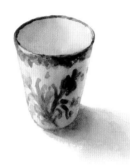

Techniques for Drawing
Dishes and Bottles
Two Lessons

Cups

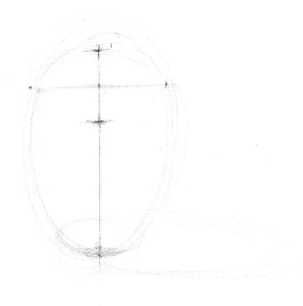

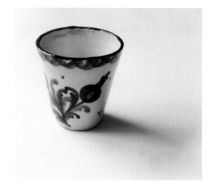

1

Draw a roughly shaped silhouette and mark the center.

The oval is always a regular oval. Draw in a vertical and horizontal line.

2

Always draw in the invisible bottom shape as well. The reason for this is the shadow.

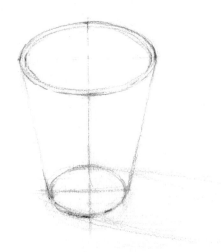

If the bottom shape is not visible, then the origin of the shadow will be unknown and the cup will look flattened out.

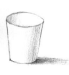

Draw lines for the shadow along the shape of the cup bottom.

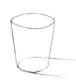

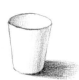

You can easily see the cylindrical shape of the cup because of the shadow width.

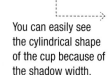

3

Always paint the base color of an unglazed cup before patterns are drawn on.

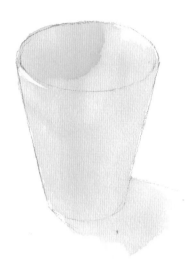

Yellow Deep
+
Opera

4

Before the paint dries, paint in the shadow.

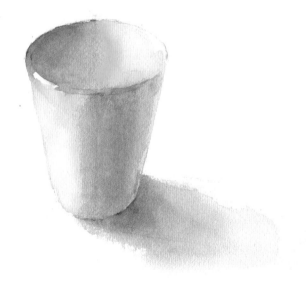

Lavender
+
Compose Blue
+
Opera

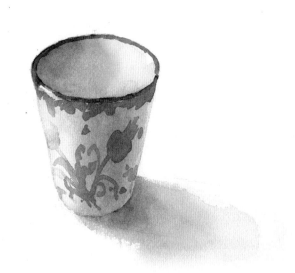

5

After painting the light and shadow on a plain cup, paint in the pattern. This is the most basic of basics.

Point

Add the pattern only after giving your cup a three-dimensional feel. Paint it using the same procedure as an artisan: "Form the shape, and then paint the patterns in last."

Cobalt Blue

Complete

Hand-painted vases and dishes are very popular as a motif. Some people draw patterns carefully with a pencil, but painting by carefully tracing these lines means that your motif loses its dynamic realism. Just by doing some proportion mapping, it's as if you have become a "pottery painter." Now let's just paint the patterns on directly. If a pattern changes a little, that's okay. To unselfishly draw dynamic, animated lines, you need a little nerve.

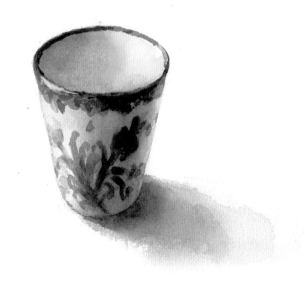

Shadow

Burnt Umber

Procedural Summary

Draw a regular oval and find a point of intersection. Draw the invisible bottom of the cup and the shadow.

Paint in the pattern after roughly painting your cup's shadow and lit/shaded parts.

❶ --------> ❷ --------> ❸ --------> ❹ --------> ❺ --------> ❻

Shadows of an Object

an object its shadow

Let's get in the habit of always making and look like they belong together.

Adding a shadow as an afterthought is like offering your guests a cushion to sit on just as they are about to leave.

Where Does a Shadow Come From?

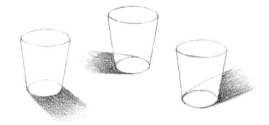

By first drawing the invisible shape at the bottom of an object, you can find the shape of its shadow.

Two Shadows

Shadow and shade. Objects are drawn using both of these.

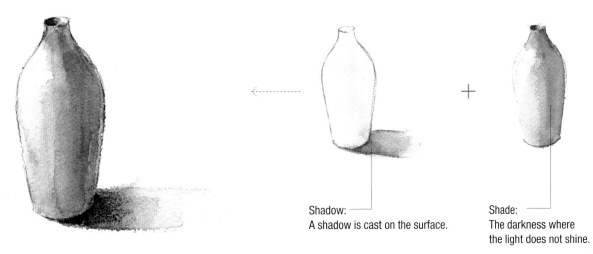

Shadow:
A shadow is cast on the surface.

Shade:
The darkness where the light does not shine.

Wine Bottle

This is a common outline for any shape of bottle, vase, can, etc. If you master this method, there will be no need to fear drawing solids ever again!

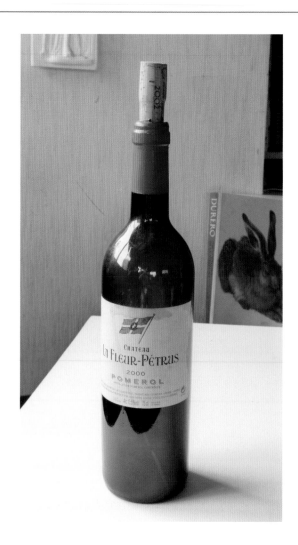

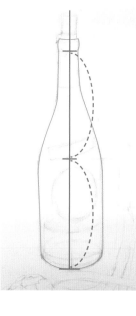

1

Using a pencil, measure the bottle neck-length. Use this unit to measure the body length by sliding the pencil down the bottle. For the bottle shown above, the body measured a little over four bottle neck-lengths. Note that you can use a ruler to draw a center line, which will be erased later.

Since the wine bottle used this time has a shoulder, it is easy to set the reference point. But you can also set the reference point by using, for example, the label position as the middle point of the bottle, etc.

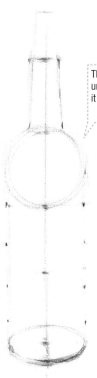

The right and left side of the shoulder can easily become uneven. To prevent this, first draw a circle and then make it fuller or smaller to balance out the shoulder.

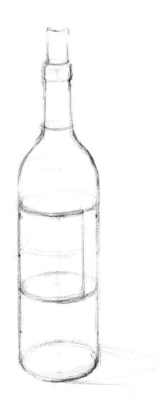

2

I am definitely against drawing outlines using a ruler. You should just think of the line as being straight and try to draw it that way using your body. That is how dessin (sketching) should be. Drawing lines by using a ruler, as in blueprints, makes those lines stand out and not blend in with all the other lines. It is okay if the line is a little crooked and twisted. What matters most is the overall feeling!!

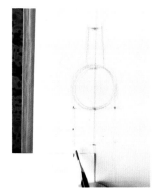

3

I will repeat it again and again. What is important when you do dessin is to explore shapes. Even if you cannot see them, imagine the oval shape at the bottom and the circular shape for the mouth of the bottle and then try to draw them. There is a big difference between drawing and then erasing as compared to not drawing at all. With that being said, draw the label after drawing the oval shape for the bottom of a bottle.

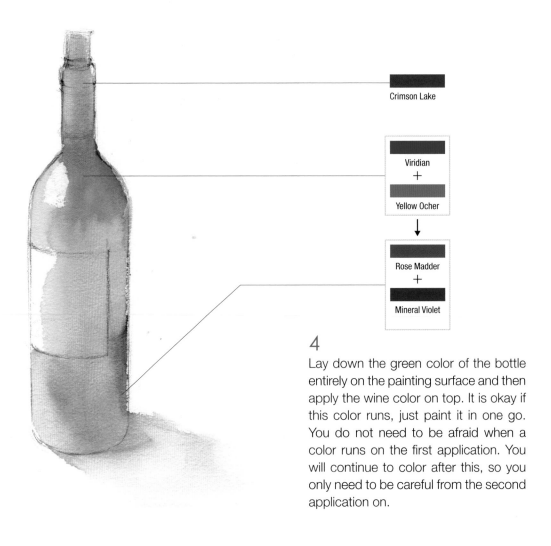

Crimson Lake

Viridian
+
Yellow Ocher
↓
Rose Madder
+
Mineral Violet

4

Lay down the green color of the bottle entirely on the painting surface and then apply the wine color on top. It is okay if this color runs, just paint it in one go. You do not need to be afraid when a color runs on the first application. You will continue to color after this, so you only need to be careful from the second application on.

If you are not conscious of the roundness of the bottle, the label becomes flat.

When you draw the label as if it is following the roundness of the bottle, it has more of a three-dimensional effect.

If you put off coloring the label, only the label portion will look flat.

Give roundness to the label portion just like the rest of the bottle.

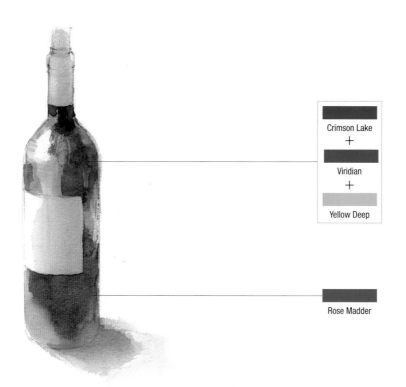

Crimson Lake
+
Viridian
+
Yellow Deep

Rose Madder

5

After the image is dry, start to apply color a second time. Use less water than the first application.

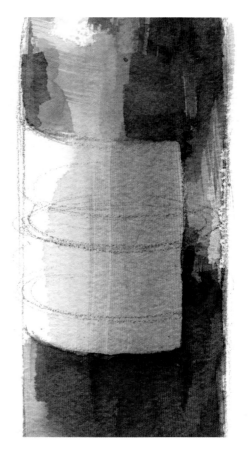

6

After giving the bottle its roundness, pencil in an oval shape and then draw in the letters for the label.

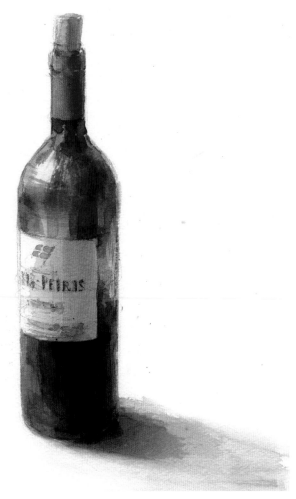

Rose Madder

Green No. 2

Complete

Might I have overdone it a little bit?

Procedural Summary

Flesh out the line as you measure.

Grasp the points where the shape starts to change.

Give the bottle its roundness even as the colors run.

Use less water to add paint.

❶ ----------> ❷ -----------> ❸ ------------> ❹ ---- Dry ---> ❺ -----------> ❻ -----------> ❼

Sketches • Proportional Mapping • Dessin

For rough sketches, deciding the size and position of objects, with thoughts like "place an apple around here and place a glass here," is called "proportional mapping." Rough sketching is making shapes after you have mapped out the proportions but before laying down watercolors. Depending on personal preference, there are certain people who sketch roughly and then give their best effort only after holding a paintbrush. On the other hand, there are those who start to color only after thoroughly sketching everything. Everyone has a procedure with which they feel most comfortable. However, those who roughly sketch may have an experience like this: "I regret not being careful with the composition because I was in a hurry to color." Those who sketch too thoroughly get tired of just sketching and drawing in small details so that the picture actually becomes tense. What is important here is that you move your hand while always thinking of the image as a complete work. Dessin and sketching have the same meaning when it comes to transparent watercolors. However, "looking at a shape" does not mean "looking at the outline." To give three-dimensional effects like bulging out and caving in, drawing the light and dark boundaries properly is very important.

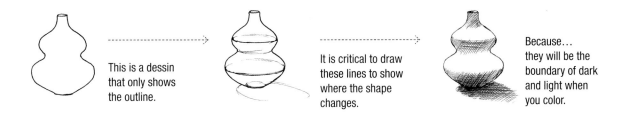

This is a dessin that only shows the outline.

It is critical to draw these lines to show where the shape changes.

Because... they will be the boundary of dark and light when you color.

The first application of color and dessin of the wine bottle

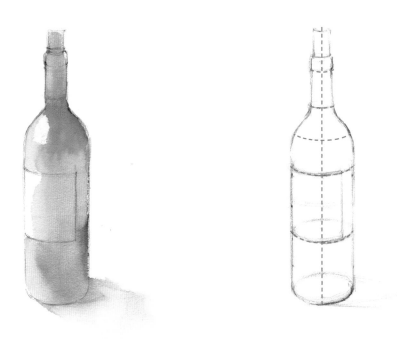

65

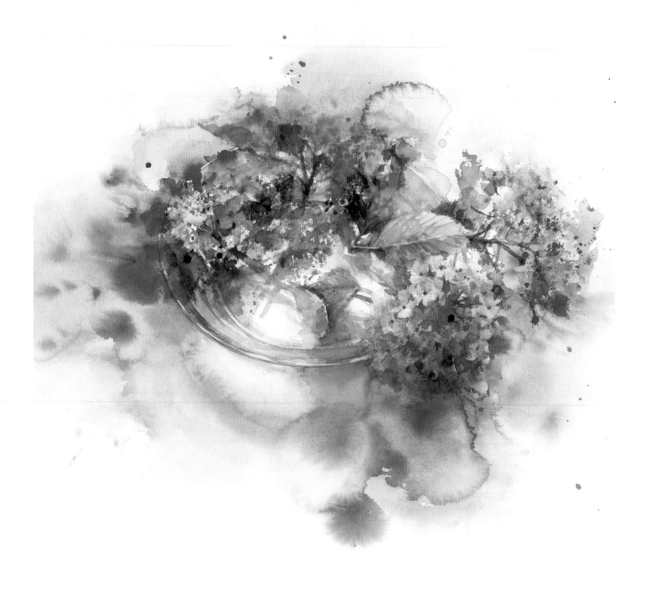

Tegami o Kaku Hi (Letter-writing Day)
42 x 50 cm / 16.5 x 19.7 in.

Hydrangea is a tranquil flower. It's never meddlesome, even when I write a letter.

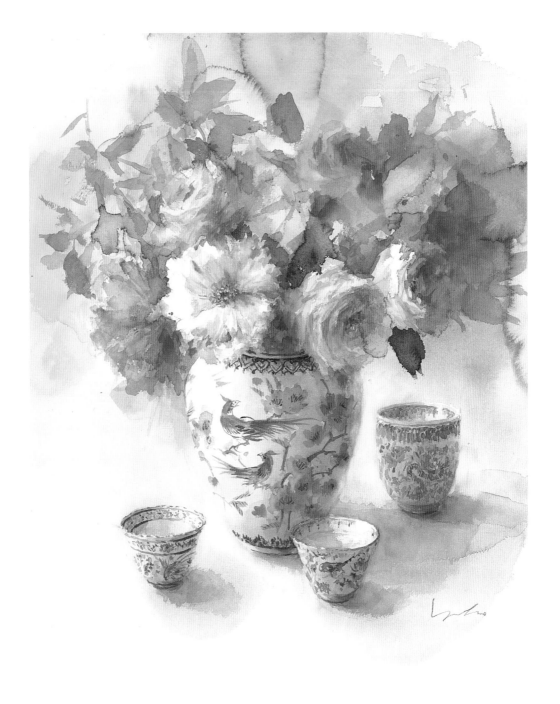

Four birds are calling out in the
distance of Shangri-la.

Yonwa no Tori (Four Birds)
53 x 43 cm / 21 x 16.9 in.

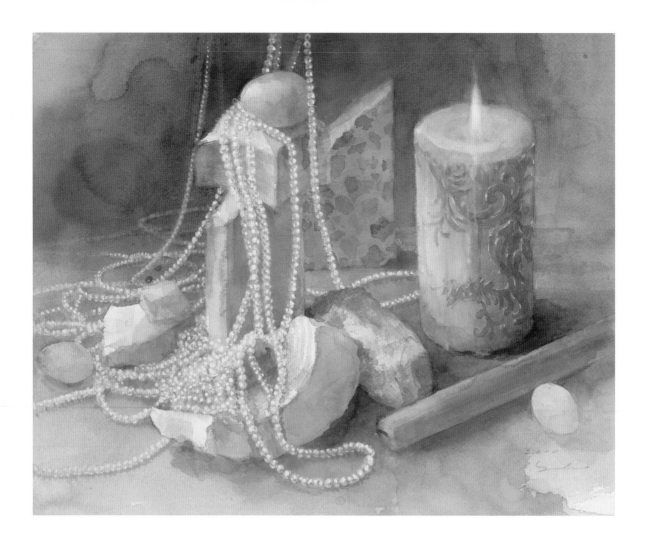

Kakera (Pieces)
32 x 40 cm / 12.6 x 15.7 in.

Collecting pieces that are all white. Items that are new, old, from the sea, or from the mountains. Just by lighting a candle, the painting's atmosphere has changed completely.

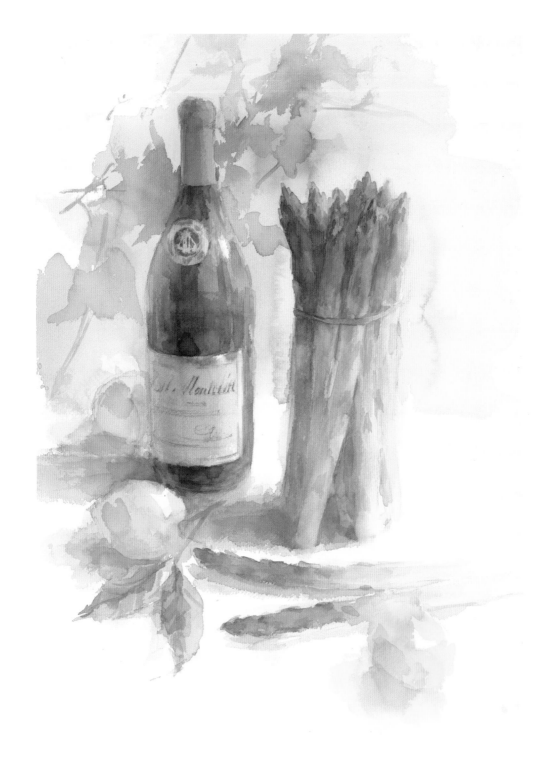

White asparagus is rare. It's a little early,
but let's celebrate a birthday.

Tanjobi (Birthday)
50 x 37 cm / 19.7 x 14.6 in.

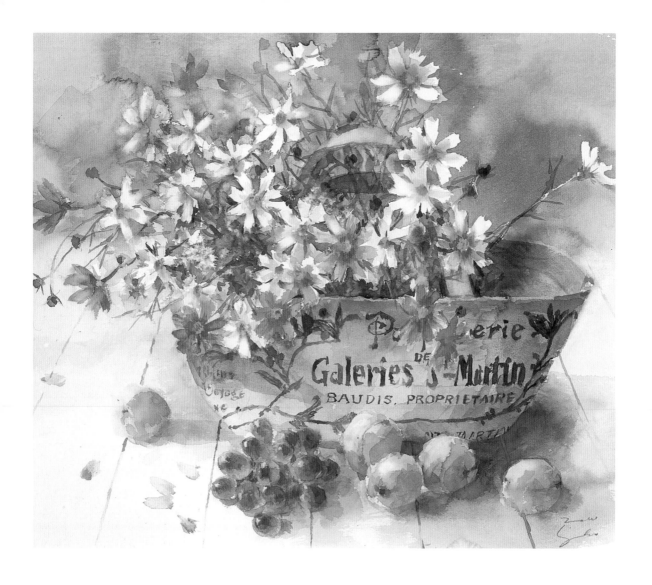

Kaerimichi (The Way Home)
45 x 53 cm / 17.7 x 20.9 in.

I threw these cosmos flowers, from my parent's home in the countryside, in a bag, and even they look as if they were raised in France.

Chapter 4

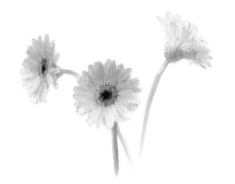

Drawing Flowers
Two Lessons

1

To connect the center of a flower and its stem, roughly map them out.

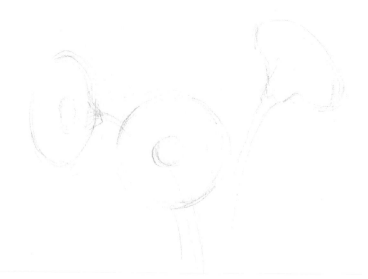

2

One fundamental of rough mapping is to start drawing from items that are in the back. Then just pile the front portions on top. Draw crosshairs to map the proportions of petals that face toward the center. Divide into quarters and draw each petal by notching.

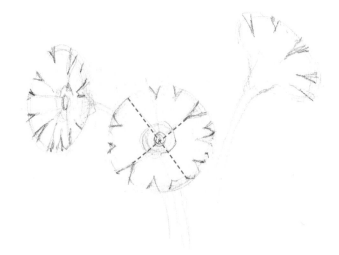

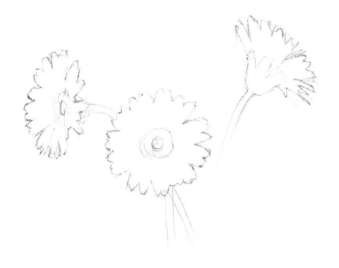

3
Carefully connect the outline. At this point, the outer petals are drawn.

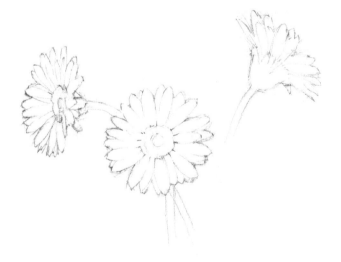

4
Put the inner petals on top.

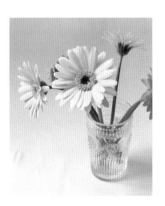

5

Look at the light and shadow on the flowers with your eyes squinted.

Flower Color

Yellow Lemon
+
Opera

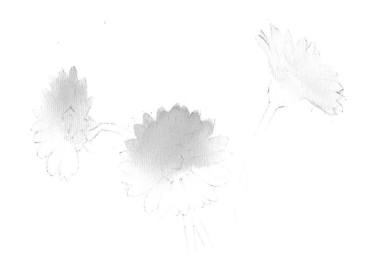

6

While the paint is still wet, paint the color for the stamen at the center of the flower. Don't worry if the colors run when underpainting.

Flower Center

Light Red

Stem

Yellow Lemon
+
Green No. 1

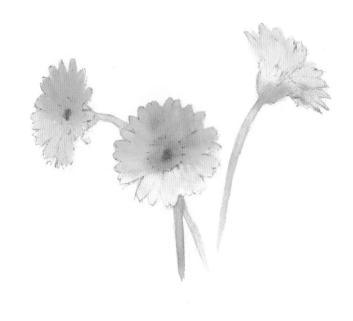

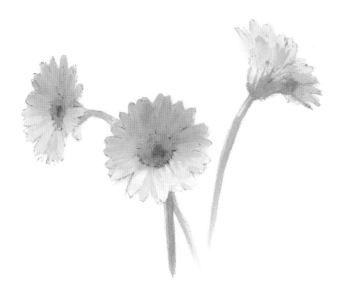

7
Once the paint dries, lay a different color on the underpainting.

Flower Color

Green No. 2
+
Yellow Gray

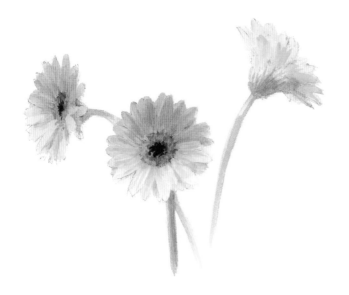

Complete

Petal

Opera
+
Lavender

Flower Center

Burnt Umber

Stem

Cerulean Blue

When You Draw Flowers

Sketching Fundamentals

Once you decide on the position and size, capture the shape by starting with objects at the back. For example, an object at the back of scenery is the horizon. Once you decide on the rough composition, start to draw the building at the back and then the tree in front.

When painting, start to paint farther back—from the sky. This applies also to when you paint flowers. Pile the petals that are in front on top of the petals at the back.

Does It Look like a Coloring? When Painting Plants, How Much Sketching Should Be Done?

Since we explained how to capture each flower for the Gerberas in the previous pages—even when they are all facing different directions—all three flowers could be sketched in great detail. However, it should be noted that when there are more flowers than in that example, it is not necessary to capture the shape of each individual flower carefully.

This does not mean that you can simply glance at the flowers you will paint. Instead, you must carefully observe how petals pile on top of each other and how the leaves grow. Then you choose the main focus by just capturing the definite shapes of a few select flowers— for the rest, just decide the position of the flower, its center, its rough size, and that is enough. There are some people who take a great deal of time with their sketches by capturing the layers of rose petals of each rose, petal by petal, for ten or fifteen roses. If you are one of those who thinks "Without doing that, I can't draw," or "I can only paint if I first draw everything I see," then I think you should do your dessin carefully. However, at the point when dessin is extremely carefully done with a pencil, some people use too much energy and end up painting flat like in a coloring book. This brings neither roundness nor depth. Switch to a paintbrush and let's do a dessin with colors this time. You are not "painting" with a paintbrush, you are "drawing with a paintbrush." In order to succeed at this, drawing sketches that are not too detailed is actually quite important.

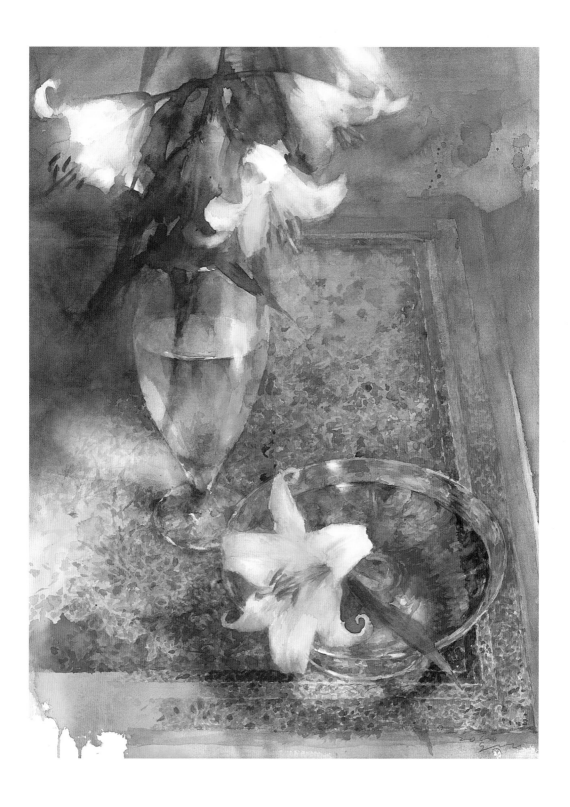

A lily that quietly began to say something
and the friends who listened to her politely.

Kokuhaku (Confession)
64 x 48 cm / 25.2 x 18.9 in.

Coloring Basics: Light and Shade on Flowers (Sunflowers)

1

Same as capturing Gerberas.

2

At first, roughly capture an outline. The gap-like appearance becomes the primary emphasis when capturing the shape.

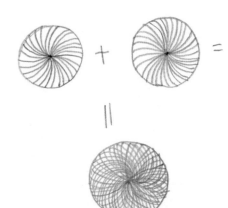

A pattern of two swirls overlapping each other makes the center of the flower. Pollen is the same. And, of course, seeds are too.

3

Connect the contours of the flower and erase the outline.

4

Draw the front petals on top. Of course, you can still draw a sunflower without carefully drawing all the petals in this manner. However, knowing how to really capture a certain type flower is helpful for when you later draw flowers of the same type.

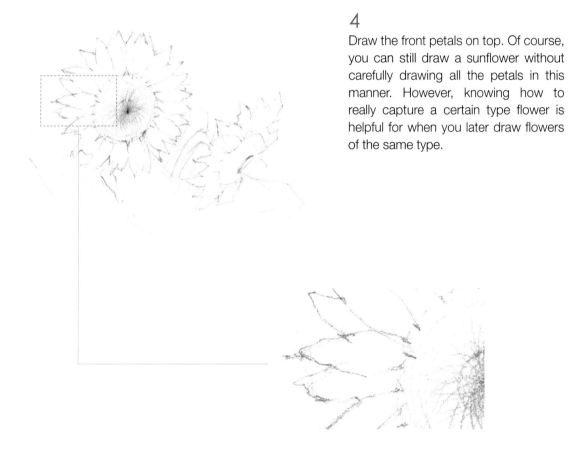

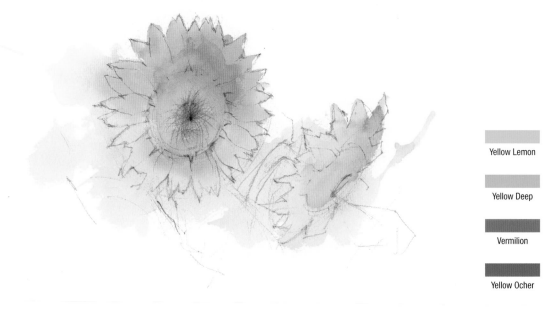

Yellow Lemon

Yellow Deep

Vermilion

Yellow Ocher

5

Paint yellow and a color that is close to orange all at once. You can define light and shade by looking at the painting with your eyes squinted. Don't leave the center unpainted while painting the petals only in yellow; rather, paint the petals and center together. Also do not become too convinced that the center is brown.

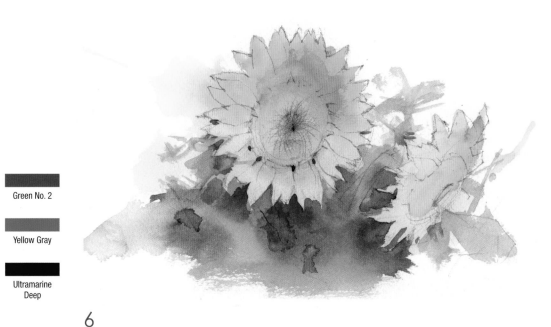

Green No. 2

Yellow Gray

Ultramarine Deep

6

Also remember the leaves are not just green. You need to add some yellow and blue shades at the same time as well.

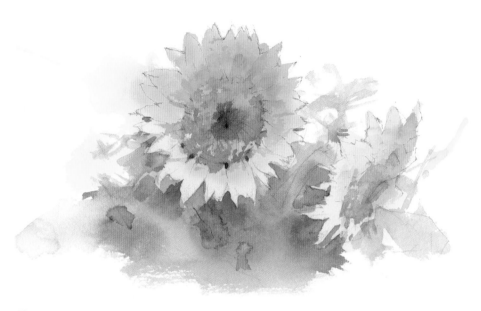

Opera
+
Yellow Gray

7

Add a three-dimensional feel to the center. Look closely to determine where the center is concave or convex.

| Procedure 5 | ◌ : The outline when it was sketched. | Procedure 7 |

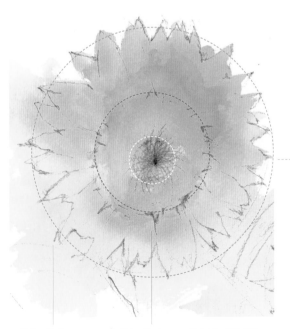

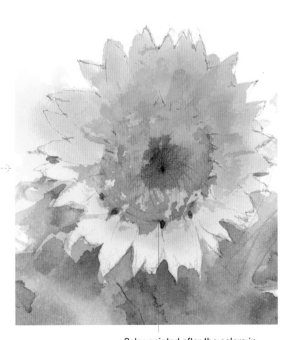

Color that was ┈┈┈▷ Color that was painted while the
initially painted. initial paint was still wet.

Color painted after the colors in
Procedure 5 had dried.

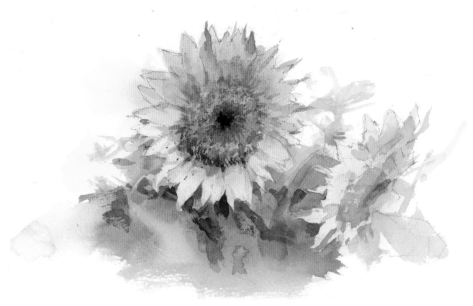

Burnt Umber

Prussian Blue

Complete

I am a stickler for painting in the stamens.

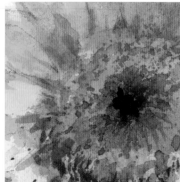

The Reason Why I Was Particular about Drawing "Stamen."

The center of a sunflower is thick and is the location of the "stamen/pistil." Seeds are packed in there as if they are filling the sunflower's heart. Certainly, this is the heart of the sunflower.

I cut sunflowers that were grown in the garden at my parents' house and painted them in my atelier. After that, I took them out of the water and left them there, but before I knew it the jam-packed seeds had begun to grow. Even as the sunflower began to die, it put all its energy into its seeds and they metamorphosed splendidly. The sunflower did exactly what it was supposed to do—I was really impressed.

As for the sunflower, paint the petals carefully but also paint some round slightly brownish spots for the stamen/pistil. Are we done with it just like that? Please thoroughly observe the heart of sunflower.

Let's Use Flat Brushes!

Flat brushes are used for painting a surface evenly or for painting a large area. However, after loading the brush with a watercolor, if you shape the brush into a claw by using the tip of your finger, you can then paint the same pattern over and over by tapping the brush on any surface. This type of brush handling is often used for painting flowers. I also use it for painting the stamen/pistil part of the sunflower.

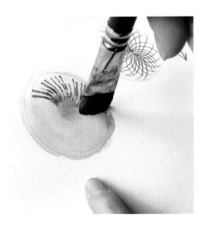

Cosmos — Drawing Them with Scenery

Draw While Capturing the Shape of a Flower

How the petals of cosmos flowers are attached.

The lily is two triangles combined together.

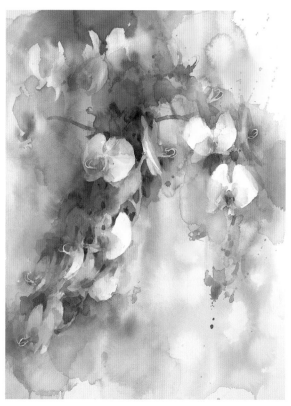

Hydrangea is five lumps.

Yume (Dream) 40 x 52.5 cm / 15.7 x 20.7 in.

When drawing an orchid, I realized that it is easier to capture its form if you first draw in the contours, represented by the dotted lines, that connect to the central line.

Paint by Following These Procedures

 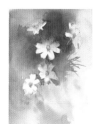 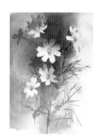 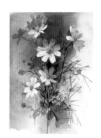

❶ ────────> ❷ ────────> ❸ ────────> ❹ ────────> Complete

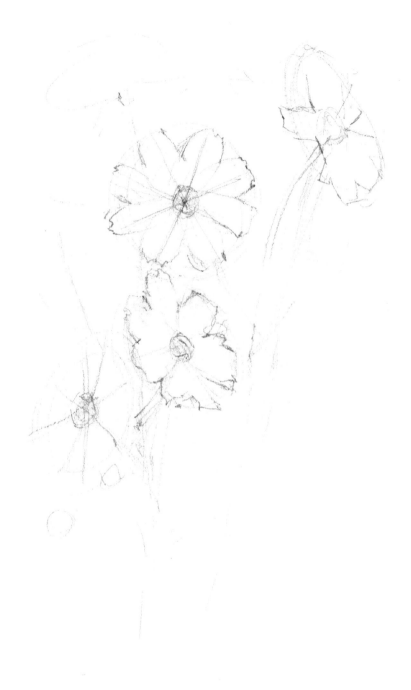

1

Cosmos flowers have eight petals. Since the petals are directly across from one another, drawing a straight line makes them easier to sketch. Similarly, for other flowers that have fewer petals, start by understanding their distinctive features.

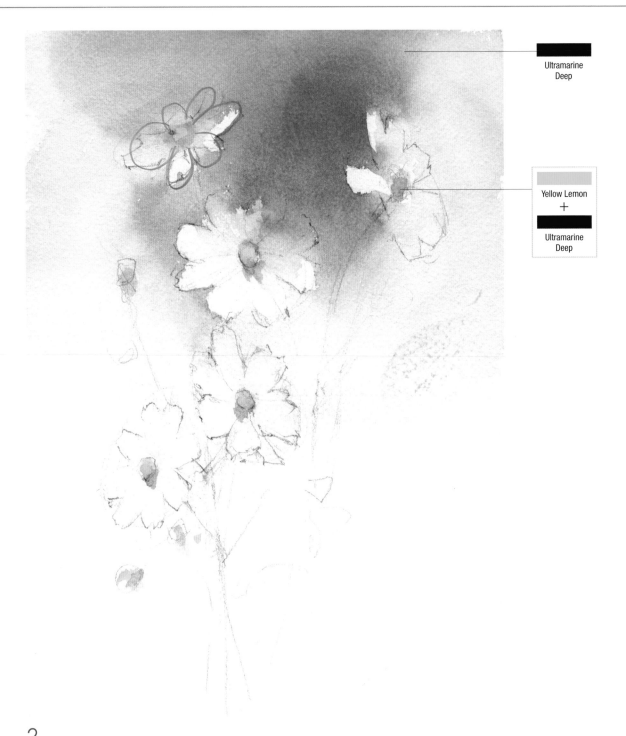

Ultramarine
Deep

Yellow Lemon
+
Ultramarine
Deep

2

While remembering to leave the lighter parts of the flower alone, apply clean water to the whole surface with a flat brush and then paint ultramarine over it. Blend green below for leaves. Since the cosmos flowers are swaying under a blue sky, be careful not to make all their contours too obvious or they will become flat, like pressed flowers.

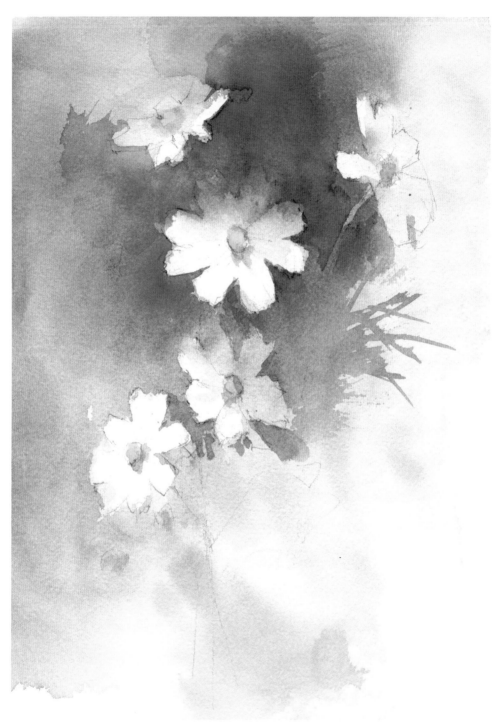

3

Once the paint has dried, start painting the shape of each flower from the outside to the inside.

Ultramarine
Deep
+
Mineral Violet

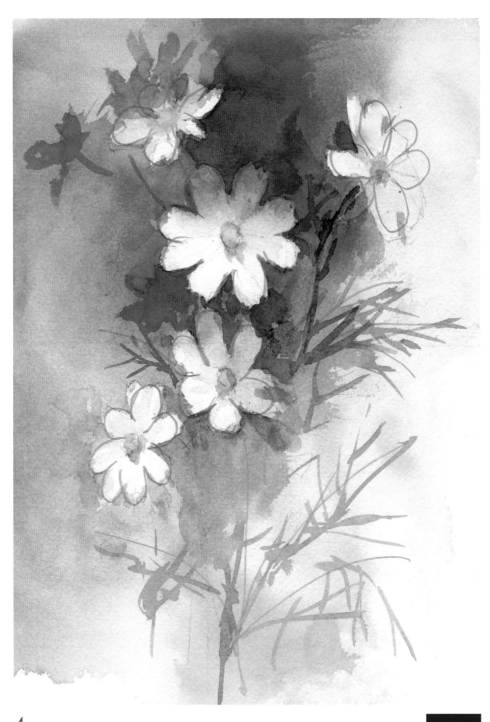

4
Paint leaves at the same time.

Terre Verte

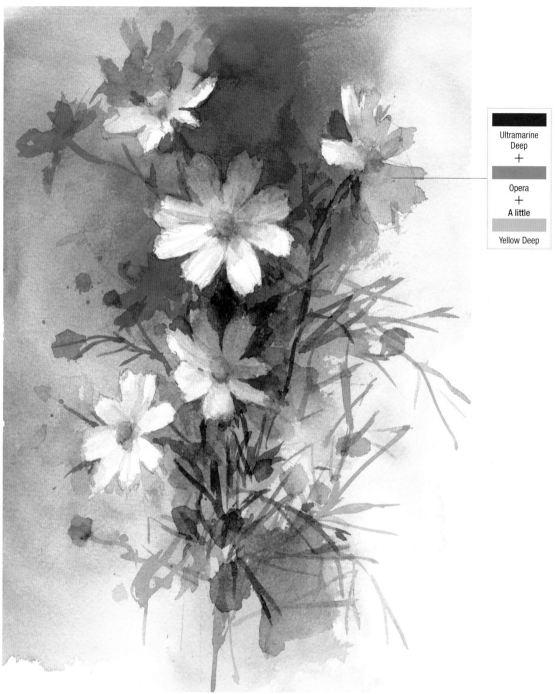

Ultramarine
Deep
+

Opera
+
A little

Yellow Deep

Complete

Add a three-dimensional feel to the stamen, and bring the background color that hangs in the air out to the front as well.

Thinly

Opera
+

Yellow Deep

Opera
+

Ultramarine
Deep

Roses — Combining Different Roses

1

I received roses that had been grown in a garden and picked by hand. After roughly mapping their proportions, I finished sketching them in without fully drawing the petals.

Paint by Following These Procedures

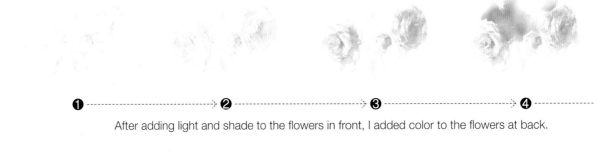

❶ - - - - - - - - - - -> ❷ - - - - - - - - - - -> ❸ - - - - - - - - - - -> ❹ - - - - - - -

After adding light and shade to the flowers in front, I added color to the flowers at back.

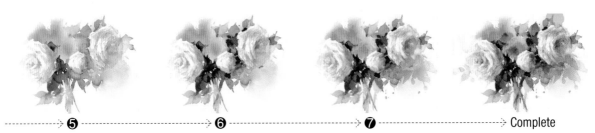

- - - - -> ❺ - - - - - - - - - - -> ❻ - - - - - - - - - - -> ❼ - - - - - - - - - - -> Complete

Depending on the color of the flower next to it, the painting method for the contour or color of the leaves will change. Then, paint a darker color to complete.

2

With your eyes squinted, divide in two—light and shade.
Paint the front roses.

Vermilion
+
Opera
+
Lavender

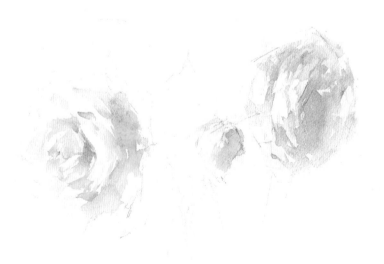

3

Since the light is coming from the left side, add lavender to make the right side darker, even though both flowers are the same.

Vermilion
+
Opera
+
Lavender

91

4

As for the roses at the rear, moisten the surface with clear water first and then drop watercolor onto it.

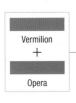

Vermilion
+
Opera

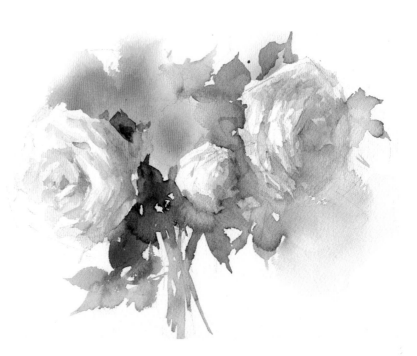

5

When painting the leaves, make the contour of the left side of the flower obvious and make the right side blurry.

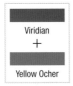

Viridian
+
Yellow Ocher

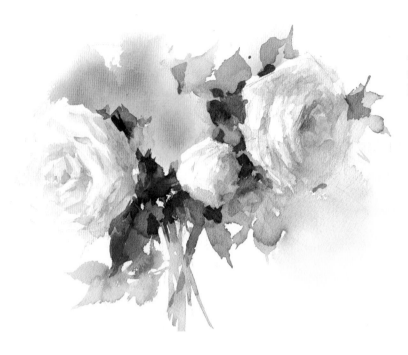

6

After the painting dries, add even deeper colors to the leaves.

Viridian
+
Light Red

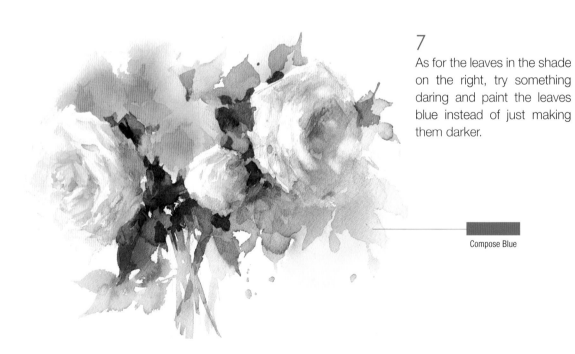

7

As for the leaves in the shade on the right, try something daring and paint the leaves blue instead of just making them darker.

Compose Blue

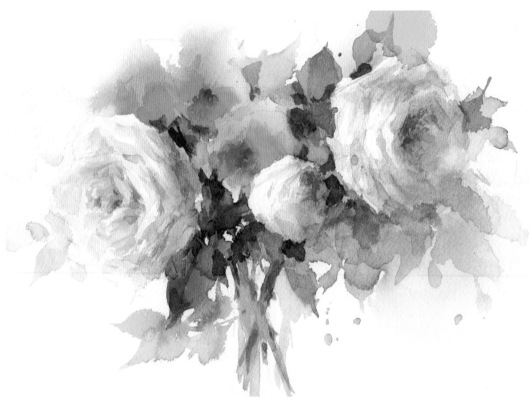

Complete

I painted over some parts with opaque white. It is not because the unpainted white part, which I purposefully left, had disappeared. Rather, I painted over those parts on purpose in order to bring out the thickness of the white petals.

Opaque White

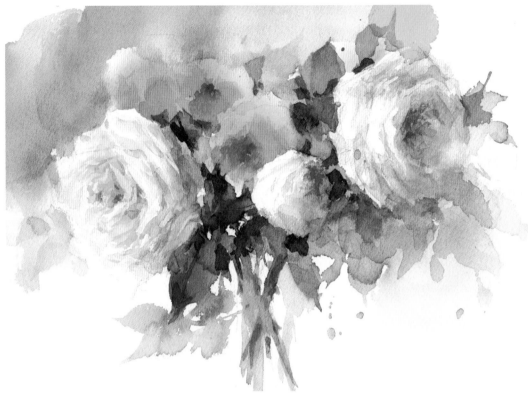

Painting the Background Color

Add a background color in order to accentuate the roses more than they are accentuated in the painting on the left.

Compose Blue
+
Cobalt Green

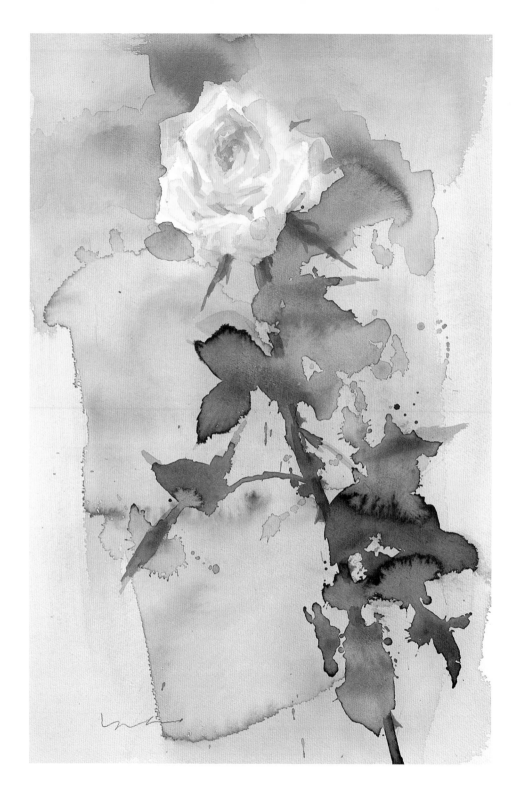

Toge (Thorn)
43 x 28 cm / 16.9 x 11.0 in.

Someone gave me a message that said, "The leaves and flowers from the roses in my garden were all blown off in a typhoon. However, if you look carefully, several leaves were caught on the thorns, as if they were protecting the very life of the flower. Nothing in this world is useless."

Watercolor Wisdom
Things to Keep in Mind

1. Don't just look at something, observe it! Observe and get a feel for it.

2. Once the approximate position and composition are fixed start to dessin from the rear. Draw the invisible shape at the bottom properly.

3. When painting, first look at the light and shade with your eyes squinted. Also, do not be afraid of bleeding watercolors in the beginning.

4. Do not paint everywhere at once. Leave the white color of paper where your painting is brightest. Make the white pop.

5. After the underpainting has dried, as your painting gets close to completion, use less and less water to dissolve the watercolor paint. (Make the concentration of watercolor paint thick.)

6. Do not adhere to fixed ideas. Freely enjoy and use your colors.

Roses

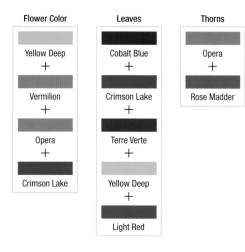

Flower Color

Yellow Deep
+
Vermilion
+
Opera
+
Crimson Lake

Leaves

Cobalt Blue
+
Crimson Lake
+
Terre Verte
+
Yellow Deep
+
Light Red

Thorns

Opera
+
Rose Madder

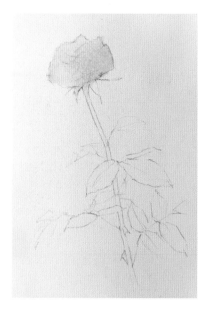

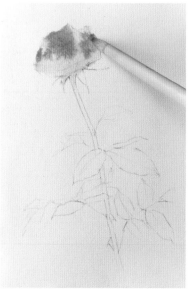

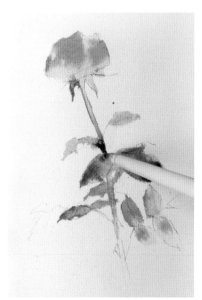

Up to this point I painted everything almost in one stretch. The evidence for that is that there are no borders between colors and the colors are blurry. There are tasks that can be accomplished in one fell swoop, without painting over something many times.

There is a benefit to doing this type of work. Using a lot water to paint delays drying and therefore allows you to think about colors.

However, painting thin watercolors like this makes them look blurry. After drying, the colors appear lighter too. Please don't be afraid to lightly wet watercolors that you want to be thicker.

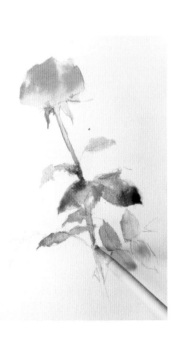

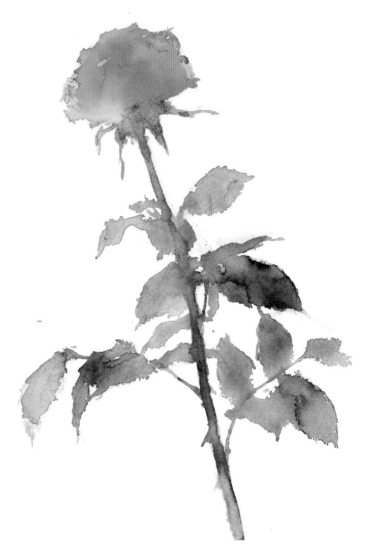

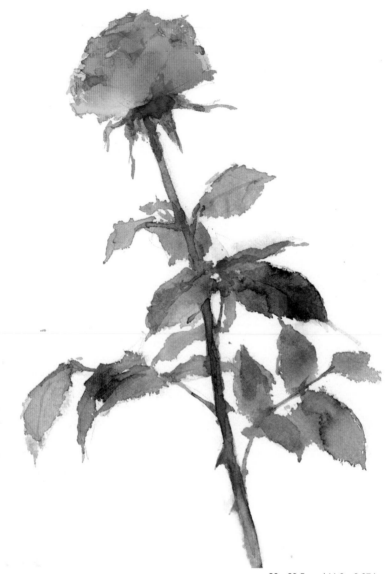

30 x 20.5 cm / 11.8 x 8.07 in.

Soft edges and blending off of transparent watercolors can lead to completely different expressions depending on the paper, the amount of water, and the weather. It is important to first do your blending off during underpainting. On the second and third application, attempting to blend off by using a lot of water rarely succeeds.

Apply clear water on paper. While the paper is still wet, lay down a select watercolor paint that is thickly wet. This brings about the most beautiful blending off. I think that is the key to transparent watercolors. For practice, lay down a color after applying clean water to your paper, and then try to finish it at one stretch. Do not be afraid of blending off. One tip for painting plants and flowers is to not rely on the intrinsic color, and when you think that it "feels like I am seeing these colors," then please boldly lay those colors down.

We say "to lay" rather than "to paint." Laying watercolors on a wet surface makes for clean blending off, just as if you are making a seal. If there is too much or too little water, it will not work well. Please also try to discover differences by using different types of paper.

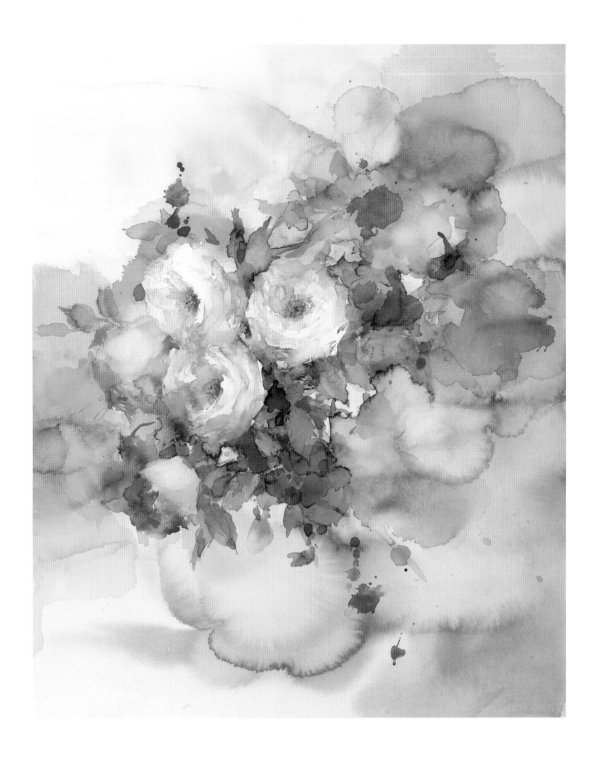

When I paint flowers, I attribute human qualities to
them. Though it seems like I am painting flowers, in
reality I could be painting a human being.

Yoi Shirase (Good News)
38 x 30 cm / 15 x 11.8 in.

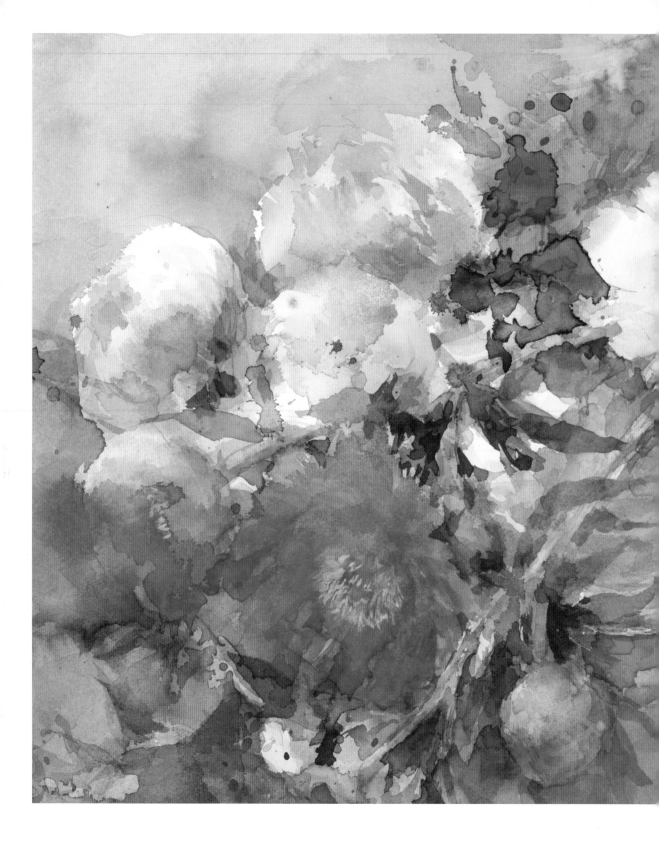

May is the time for …
33 x 55 cm / 13 x 21.7 in.

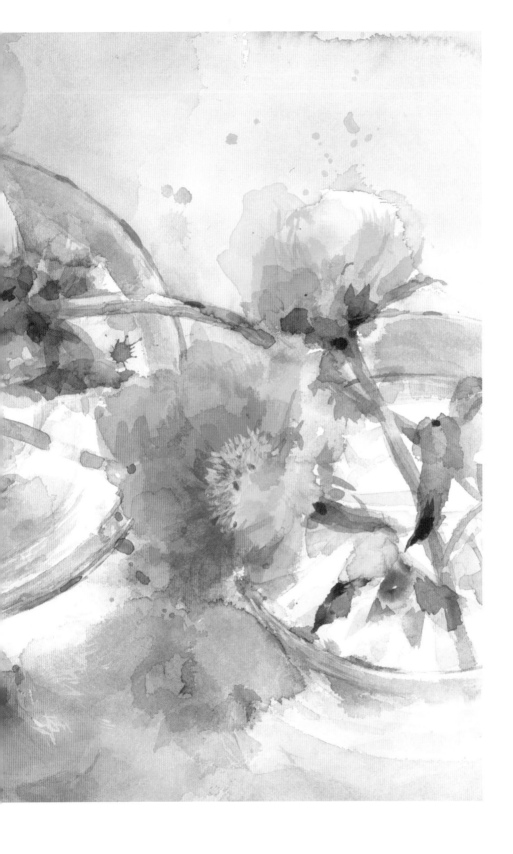

After I painted several of these pieces, my eyes finally became accustomed to and harmonized with the intense color of these flowers.

Yuko Nagayama

Born in 1963 in Tokyo, Nagayama graduated from Tokyo University of the Arts in 1985 with a major in oil painting. She received the Ataka Award and the Ohashi Award. She studied under Hiroshi Karase in the Graduate School at Tokyo University of the Arts, and graduated in 1987.

She works in watercolor, mixed media, and collages, but it is her original watercolor painting methods, in particular, that are recognized both domestically and internationally. One of her paintings graced the cover of *L'Art de l'Aquarelle*, a French watercolor magazine, that also featured an article on her demonstrations. In addition to watercolors, Nagayama also uses gold, platinum, and Japanese-style paints, which create wonderfully original translucent paintings, and the watercolor magazine *Amazing Palette* has highlighted this unique palette.

In Japan, Nagayama is known to be a pioneer of performing watercolor-painting demonstrations that have been popular since 2006. Initially she did her demonstrations at her private gallery without any advertising. However, her presentations, which let the audience members share in the depth and scope of watercolor expression, have become well-known through word of mouth, and nowadays she gives many sold-out lectures. But to this day, Nagayama still enjoys preparing motifs and performing demonstrations at her private gallery, still without any advertising.

www.nagayamay.com

You Can Paint Vibrant Watercolors in Twelve Easy Lessons
by Yuko Nagayama

First designed and published in Japan in 2012 by
Graphic-sha Publishing Co., Ltd.
1-14-17 Kudankita, Chiyoda-ku, Tokyo 102-0073, Japan

Copyright © 2014 Yuko Nagayama
Copyright © 2014 Graphic-sha Publishing Co., Ltd.

English edition published in the United States of America in 2014 by
Harper Design
An Imprint of HarperCollinsPublishers
195 Broadway
New York, NY 10007
Tel: (212) 207-7000
Fax: (212) 207-7654
harperdesign@harpercollins.com
www.harpercollins.com

HarperCollins books may be purchased for educational, business, or sales promotional use. For information, please e-mail the Special Markets Department at SPsales@harpercollins.com.

Distributed throughout the world excluding France by
HarperCollins Publishers
195 Broadway
New York, NY 10007

ISBN 978-0-06-233632-3

Library of Congress Control Number: 2014937992

Printed in China

First Printing, 2014

Creative staff
Photographs: Yasuo Imai
Book design: Yoshiaki Takagi, Haruna Okubo (Indigo Design Studio)
Editor: Mari Nagai (Graphic-sha Publishing Co., Ltd.)

English edition
English translation: Kevin Willson/Midori Willson
English edition layout: Shinichi Ishioka
Production and management: Kumiko Sakamoto (Graphic-sha Publishing Co., Ltd.)